CAPE COD AND THE ISLANDS

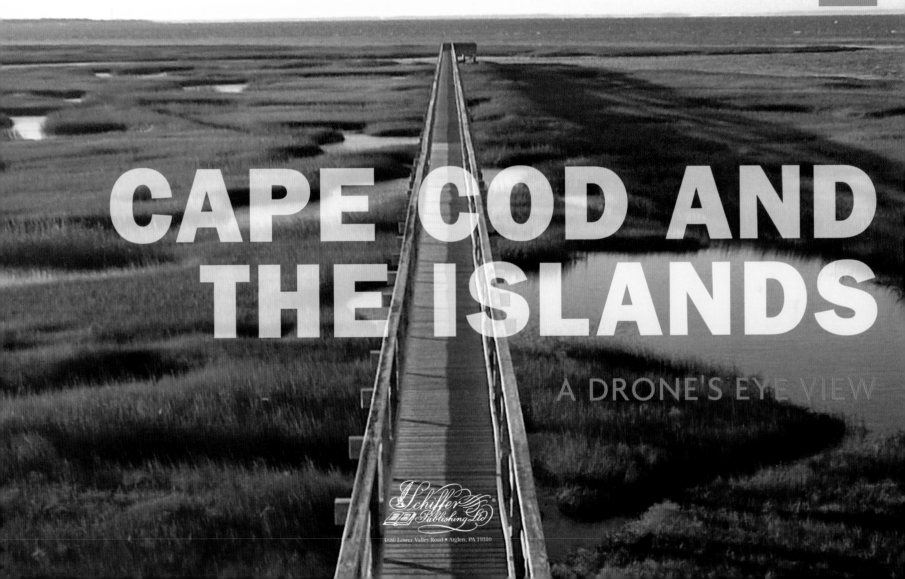

Christopher Seufert

CAPE COD AND THE ISLANDS

A DRONE'S EYE VIEW

Schiffer Publishing Ltd

4880 Lower Valley Road • Atglen, PA 19310

For Ethan & Stella

Cover design by Brenda McCallum
Type set in Agenda

ISBN: 978-0-7643-5506-6
Printed in China

Published by Schiffer Publishing, Ltd.
4880 Lower Valley Road
Atglen, PA 19310
Phone: (610) 593-1777; Fax: (610) 593-2002
E-mail: Info@schifferbooks.com
Web: www.schifferbooks.com

For our complete selection of fine books on this and related subjects, please visit our website at www.schifferbooks.com. You may also write for a free catalog.

Schiffer Publishing's titles are available at special discounts for bulk purchases for sales promotions or premiums. Special editions, including personalized covers, corporate imprints, and excerpts, can be created in large quantities for special needs. For more information, contact the publisher.

We are always looking for people to write books on new and related subjects. If you have an idea for a book, please contact us at proposals@schifferbooks.com

FOREWORD

I'm a Cape-Codder. I was born and raised here. And while I reside in Austin, Texas, my heart still belongs to Cape Cod.

Having spent the last forty years as a national and international travel photographer, I can't think of a single destination that has had such a mesmerizing effect on my photographic psyche as Cape Cod.

It is a geographic wonderland, from the Bourne and Sagamore Bridges to the tip of Provincetown. Beautiful beaches. Stunning sunrises and sunsets. Rolling sand dunes. Blinking lighthouses. Bountiful cranberry bogs. Quaint marinas and harbors. Hiking and bike trails. Boardwalks that stretch to the sea. Towering coastline cliffs. Legendary national parks. Windswept shacks and cottages.

Christopher Seufert's drone photography is simply out of this world. I love looking at his inspiring collection of Cape pictures. Fresh. Graphic. Striking. Unique. Henry David Thoreau would be proud.

—Jack Hollingsworth

Jack Hollingsworth has been published in *Travel*, *Lifestyle*, and *Portrait Photography Today*, shooting for the Four Seasons Hotel, Ritz Carlton, SilverSea Cruises, American Airlines, and Singapore Airlines, among others. He has operated commercial photo studios in Austin, Boston, New Delhi, and Singapore.

INTRODUCTION
Technical and Legal Notes

Photography with drones is still in its infancy, and for that reason this book feels like a first book for me, rather than a third. When I was starting out in photography, professionals were very much concerned about the still-developing digital SLRs—megapixels, resolution, low-light capabilities, shutter speeds, etc. Now, even the most basic point and shoot allows for printing up to three or four feet in size, and the megapixel wars are over.

Not so with drones. Professional photographers who use drones in the general fields of portraiture, weddings, landscape art, and journalism have been sent back to the races when it comes to the cameras that are attached to drones, launching their $5,000 SLR systems into the capricious skies and over the wild oceans.

The images included here have been gathered over a two-year period characterized by this great technological growth, and I find myself still striving for the quality that I'm used to on the ground. I have found, however, that it's been a great advantage to be a photographer learning drones rather than a drone enthusiast trying to learn proper photography techniques. The DJI drones I used to capture these images, (3, 4 Pro, Mavic Pro) are so smart that a childhood spent playing video games easily provides the technical ability needed.

With that said, the images included here were shot according to the guidelines of the FAA, interfacing with all of the appropriate airports and control towers. Thanks go to Chatham airport manager

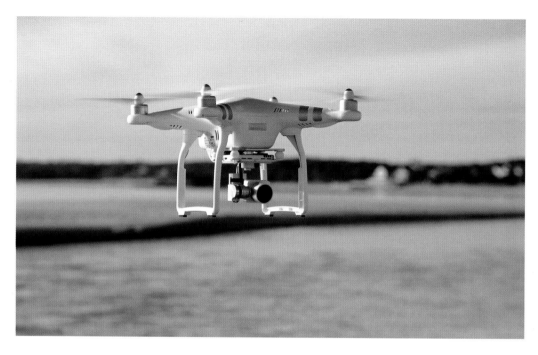

Tim Howard for his kind mentorship over this learning period. I also secured my commercial PIC (Pilot in Command) license for UAS systems from the FAA, as outlined under Part 107 in August 2016, at Plymouth Airport.

Shooting with drones on Cape Cod makes the Cape feel larger—expansive, even. Suddenly all of those sand pits, sandbars, flooding marsh trails, and brambled paths are instantly accessible. For a photographer (with two small kids) it's liberating to be able to shoot a place like Great Island or Jeremy Point in Wellfleet without the three-hour round-trip hike. The drone hovers in the air with the stability of an invisible tripod, even providing the

A DJI Phantom 3 hovering over Hardings Beach

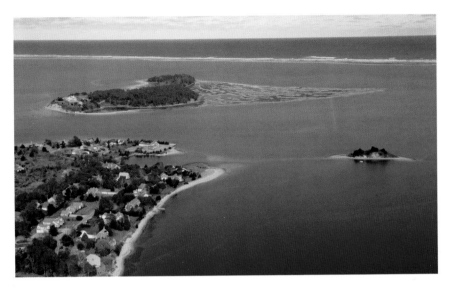

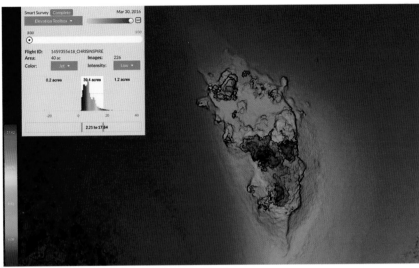

Left: Fox Island (right) in Chatham, one of many Cape Cod coastal features that are separated from the mainland at high tide.

Right: A thermal image from a 3-D mapping drone flight shows the island's acreage at high tide.

capability of shooting time-lapse video and delicate stitched panoramas, something impossible by airplane. No over-sand vehicle required, there are no ticks, and, because the drones I use can fly up to fifty miles per hour, getting shots a mile offshore over shark-traveled waters is a matter of twenty minutes or so, no boat required.

In addition to their potential for use in spotting great white sharks or tuna, drones also allow 3-D mapping (thermal/LIDAR) via photogrammetry patterns for monitoring coastal erosion, estuarine vegetation patterns (incursion of non-native species), and archeological site identification/monitoring. Software controls the movements of the drone from takeoff to landing to achieve an overlapping umbrella of images—no airplane or expensive equipment needed. The images can then be processed via cloud

software, such as Drone Deploy, within twenty-four hours.

There are drawbacks, of course, such as the legal regulations, adding to the preplanning for shoots. It is illegal, for example to take off or land from the lands of the Cape Cod National Seashore. The FAA says, however, that it is legal to fly over the national seashore as long as other regulations are followed (such as noise, and the harassment of wildlife) and take-off and landing is done on private or town lands.

Also, the small screen typically used makes for some difficulty in seeing all details of an image during flight. Hence, the great white shark on plate #31 was only caught after the fact, while reviewing the flight's video.

In the end, for me, someone who grew up tramping the marshes of my backyard and wandering the empty beaches in the

off-season, the wilds and waters of Cape Cod seem somewhat unconquerable, even with technology such as this. It is surely illusion. The Cape has as fragile an ecosystem as any other on our planet. So, perhaps it's not so unbeatable as untamable. Flying over the Great Beach, even via drone, still calls to mind the classic Cape read, *The Outermost House*.

Christopher Seufert
Hardings Beach
May 2017

Image from a 3-D mapping photogrammetry flight at Polpis Harbor, Nantucket.

Opposite Page: The final 3-D map showing the vegetation in the Smugs Ria stream area of Polpis Harbor. All measurements are inherently attached to features of a 3-D map.

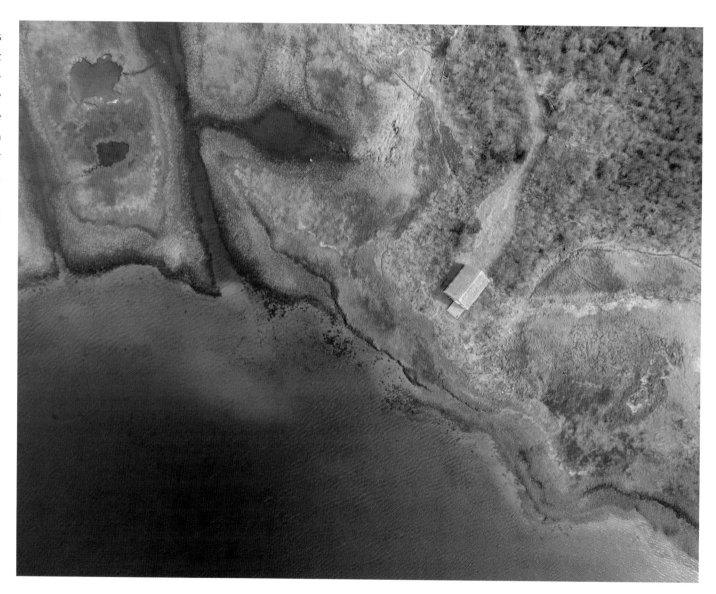

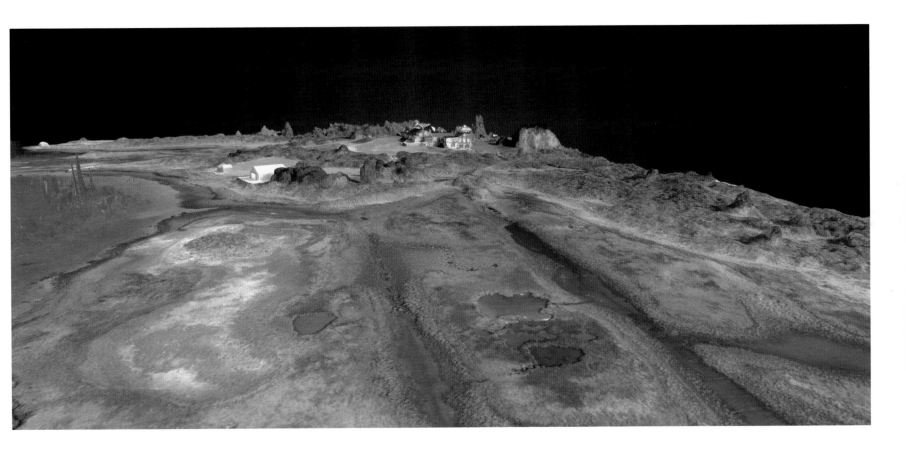

"The world today is sick to its thin blood for lack of elemental things, for fire before the hands, for water welling from the earth, for air, for the dear earth itself underfoot. In my world of beach and dunes these elemental presences lived and had their being, and under their arch there moved an incomparable pageant of nature and the year."—Henry Beston

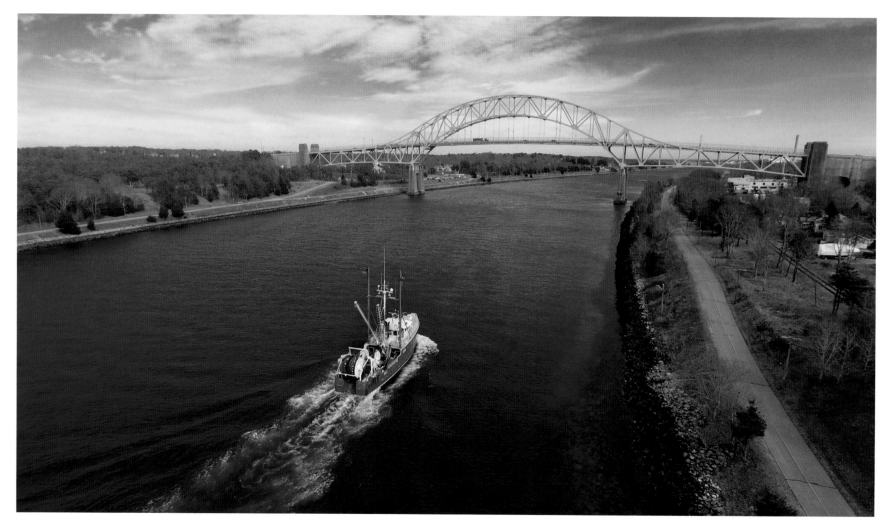

Sagamore Bridge at Cape Cod Canal

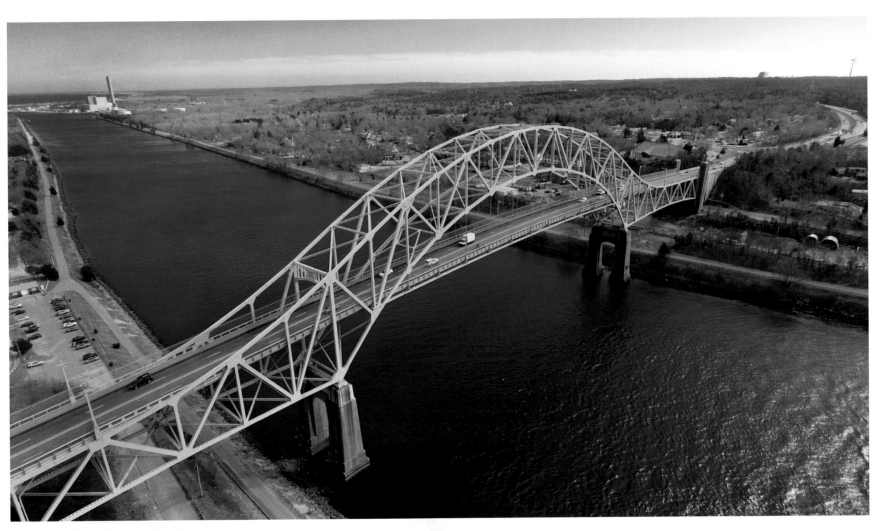

Sagamore Bridge at Cape Cod Canal

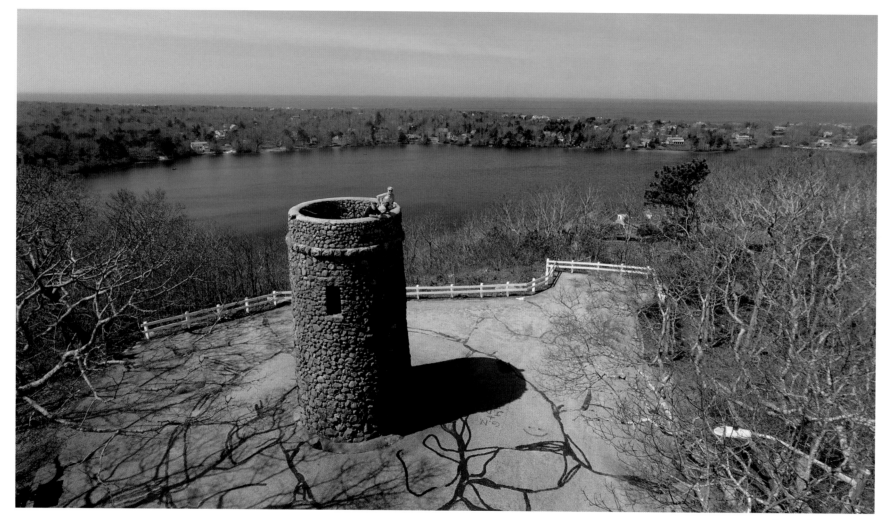

Scargo Tower, Dennis

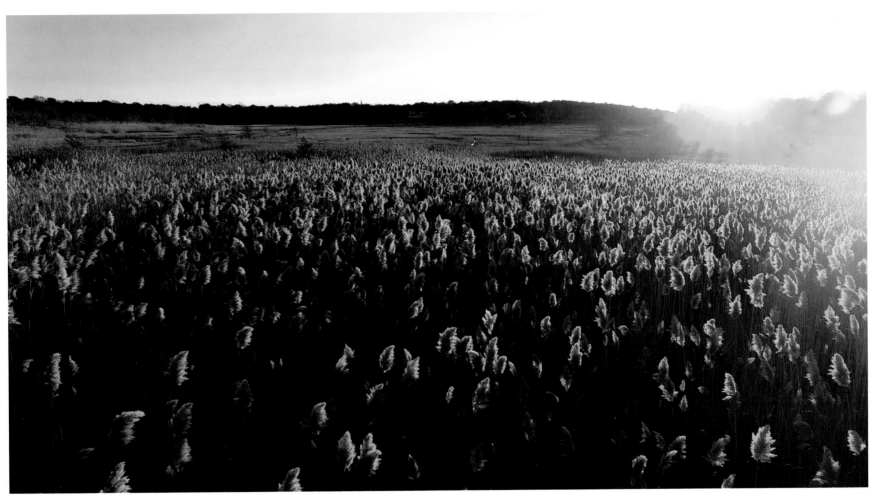

Bass Hole Marsh, Yarmouth

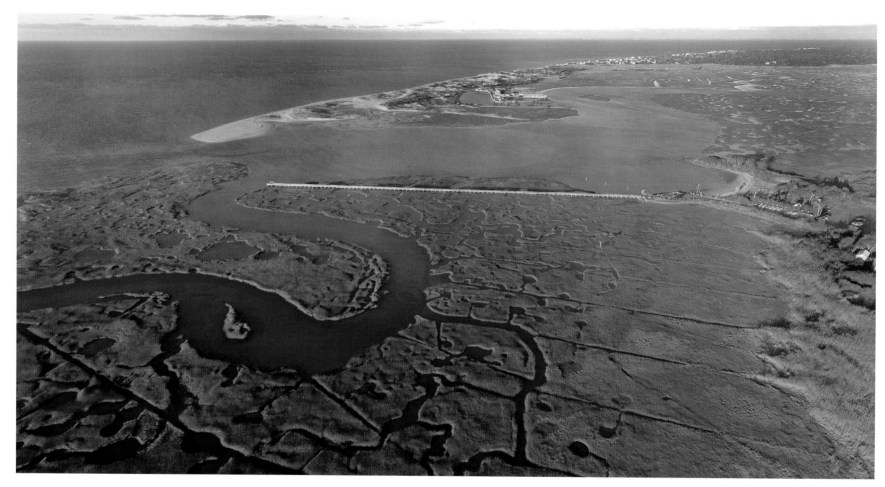

Bass Hole Boardwalk, Yarmouth

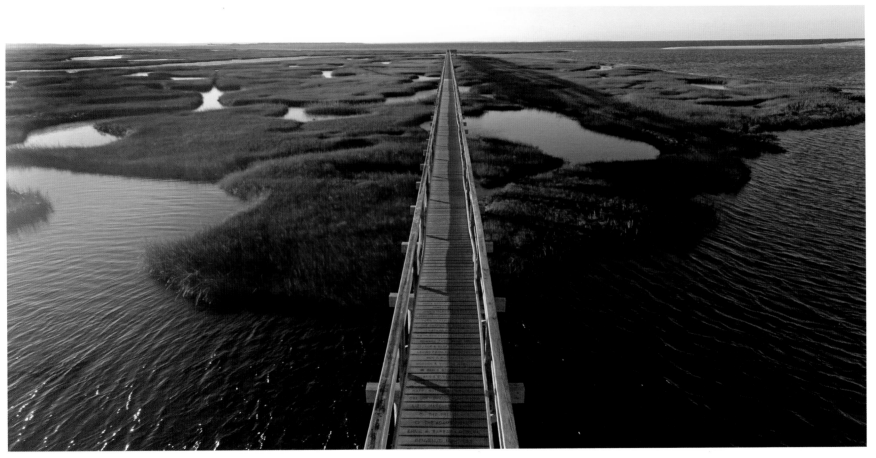

Bass Hole, Yarmouth

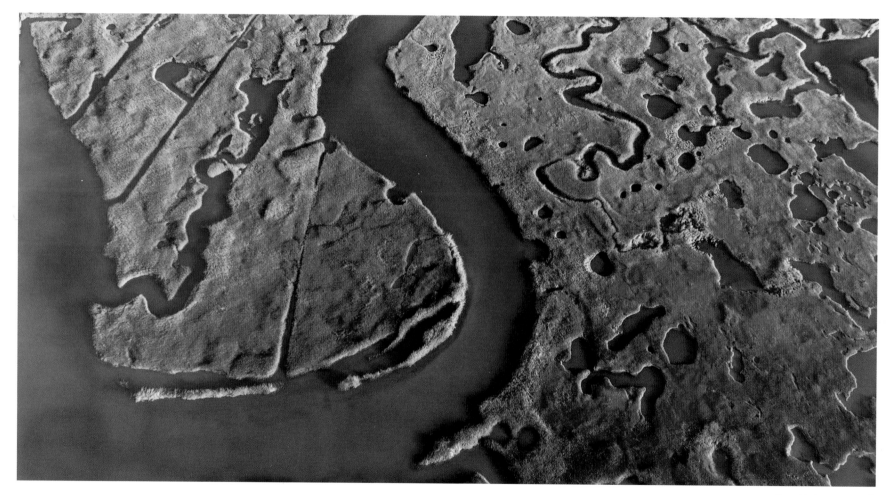

Bass Hole, Yarmouth

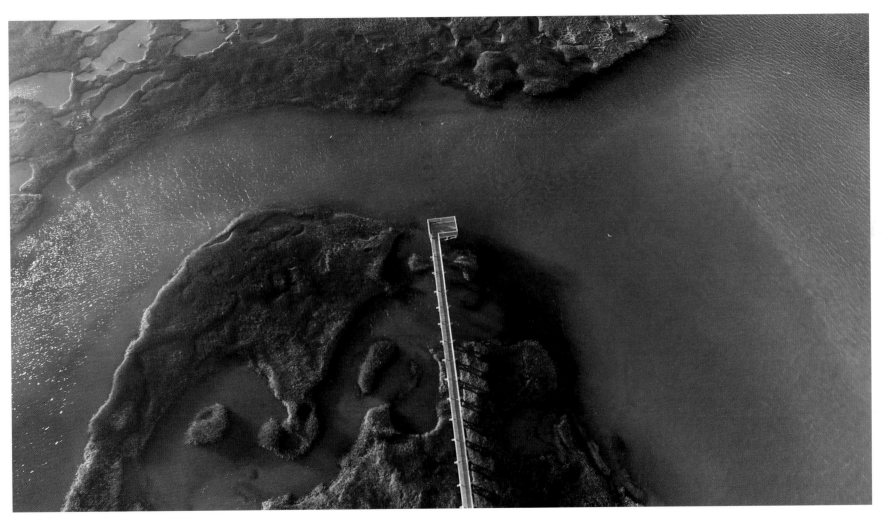

Bass Hole, Yarmouth

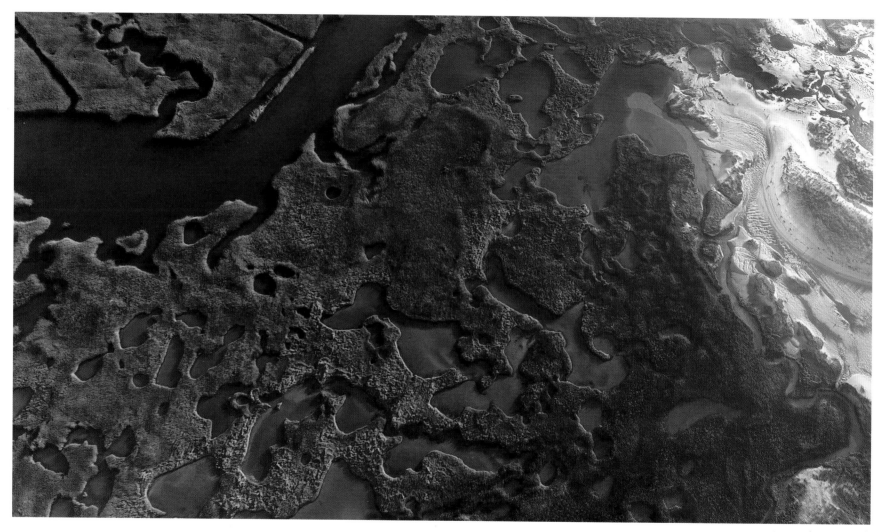

Bass Hole, Yarmouth

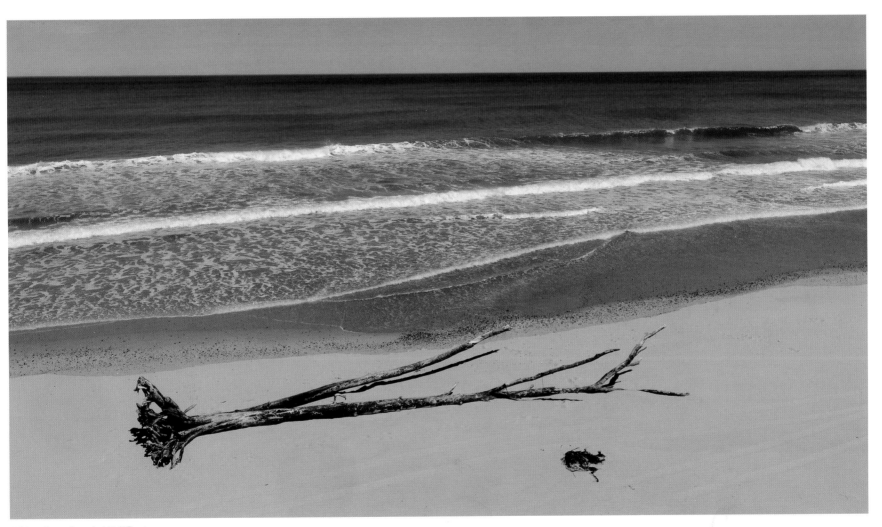

White Crest Beach, Wellfleet

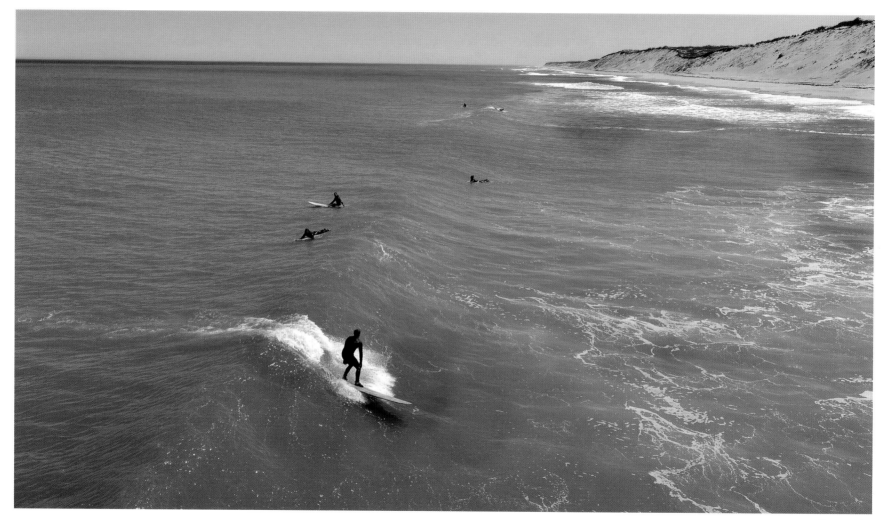

LeCount Hollow Surfer

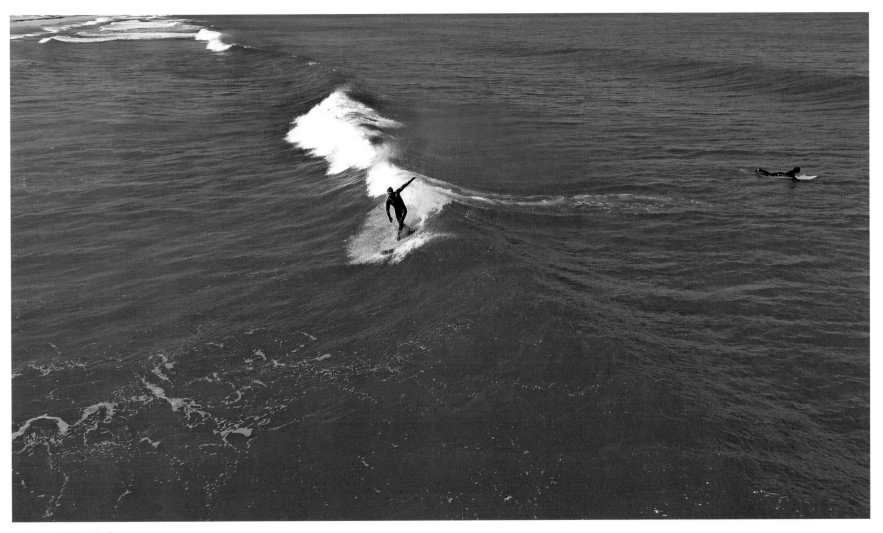

LeCount Hollow Surfer

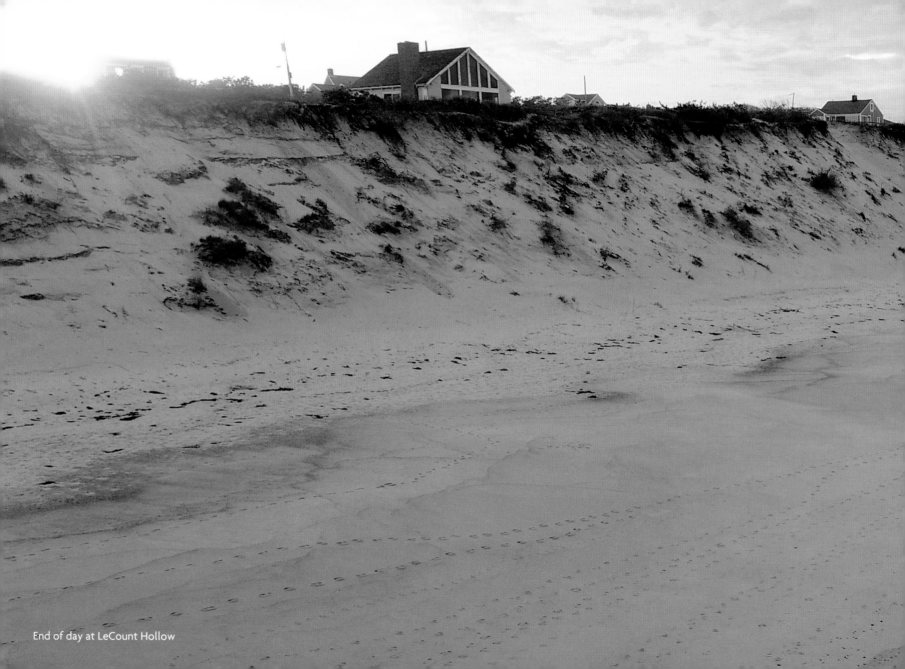

End of day at LeCount Hollow

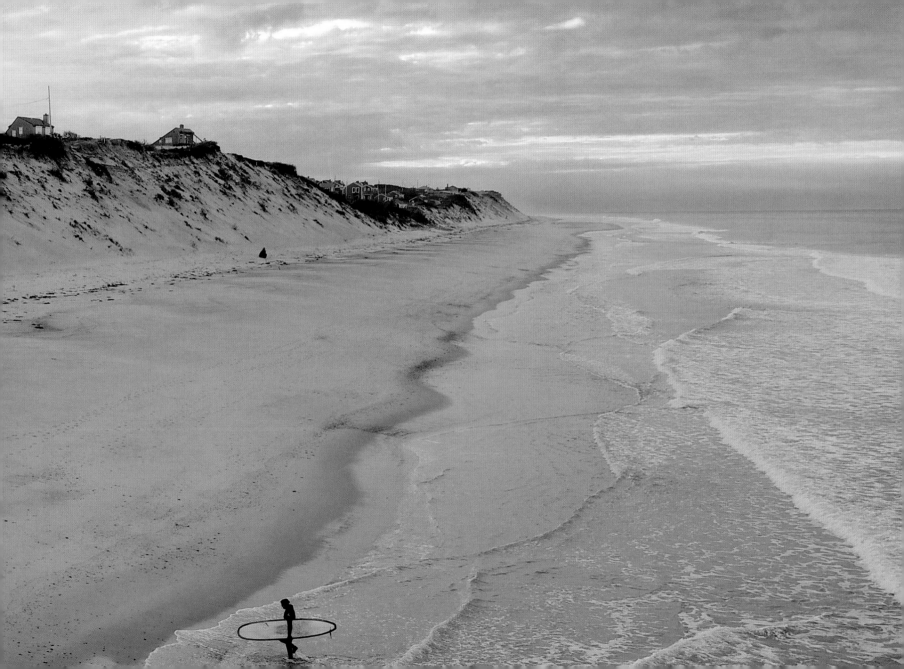

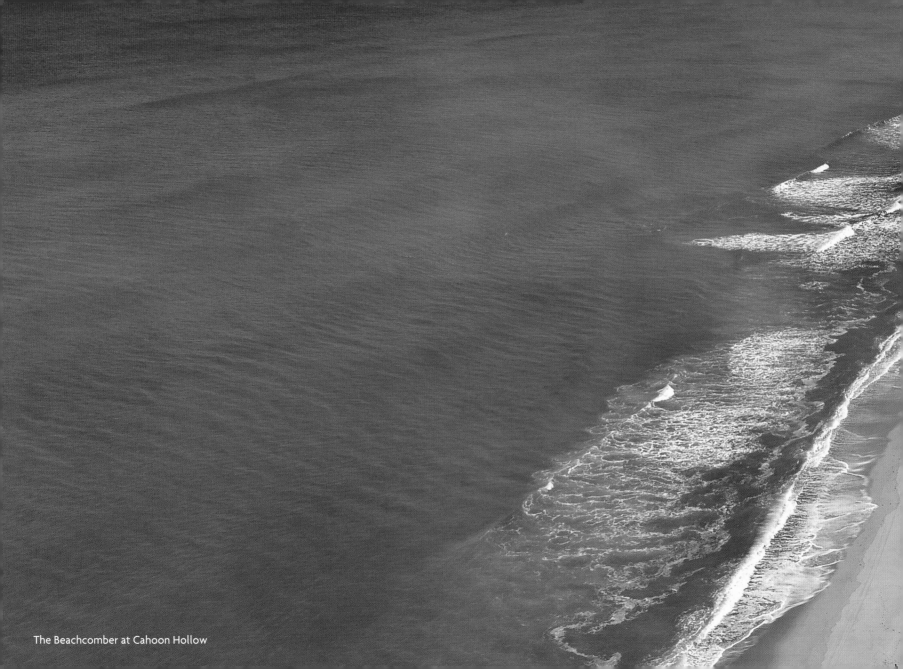

The Beachcomber at Cahoon Hollow

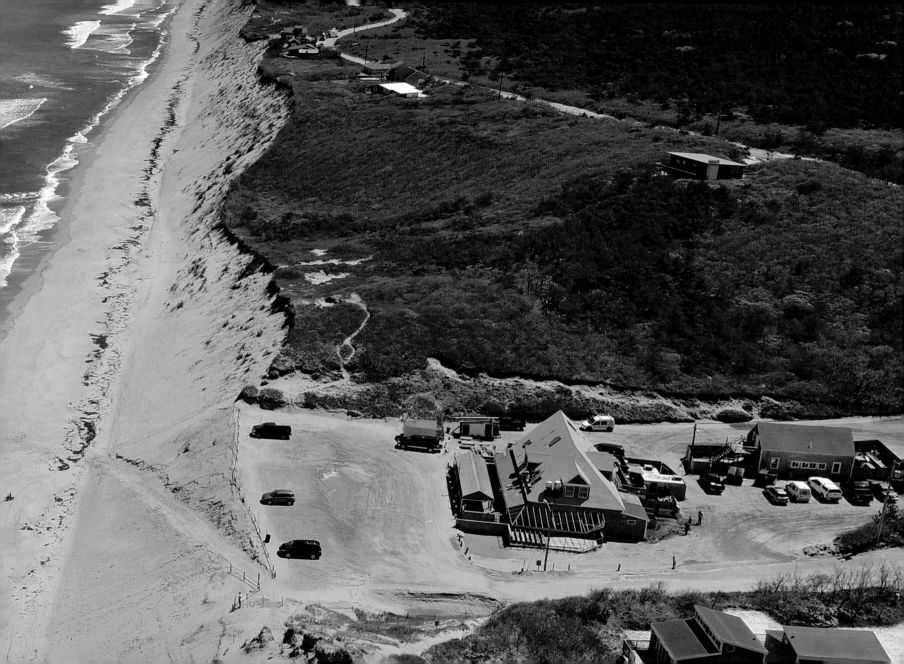

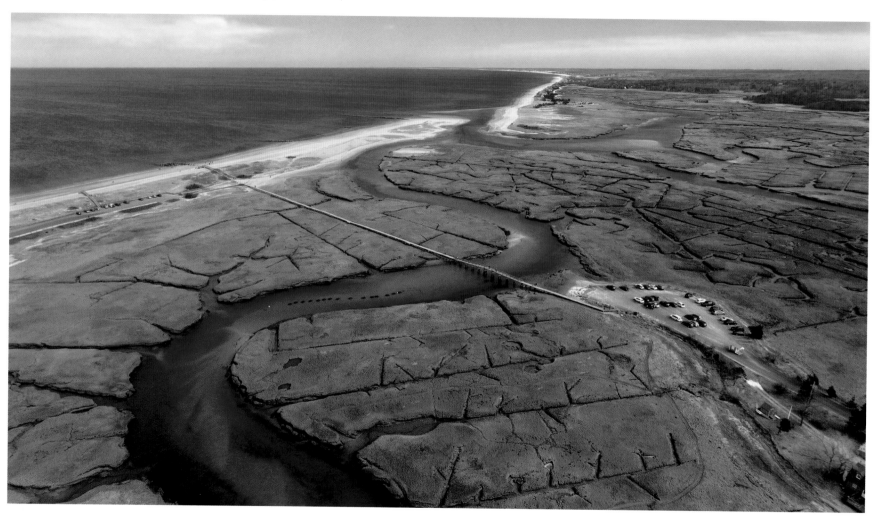

Sandwich Boardwalk & Marsh

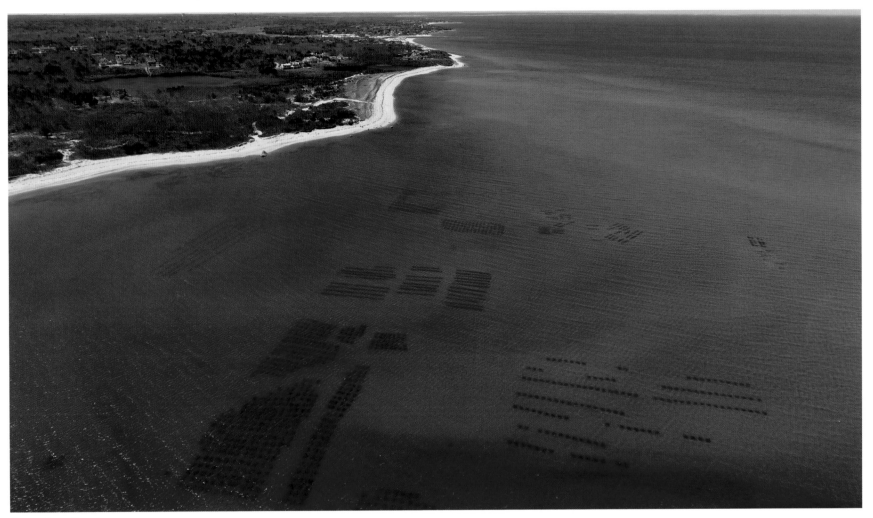

Oyster Farm, Dennis

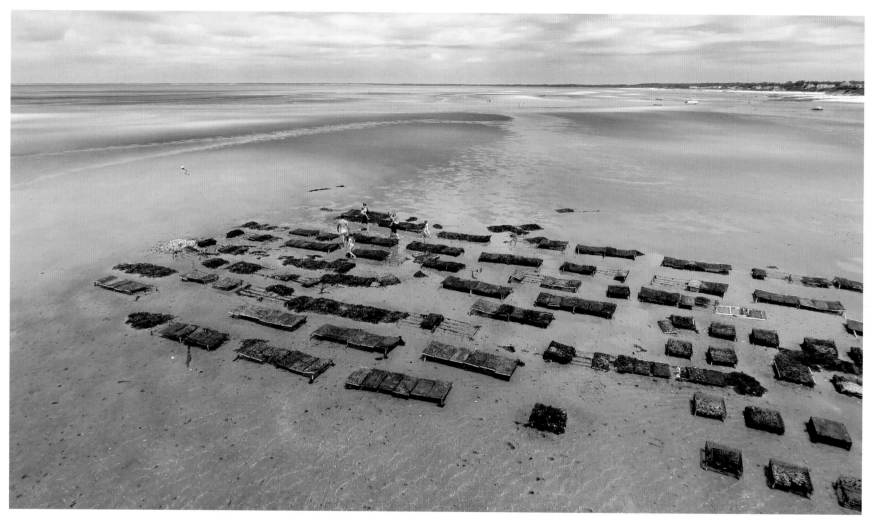

Oyster Farm, Brewster

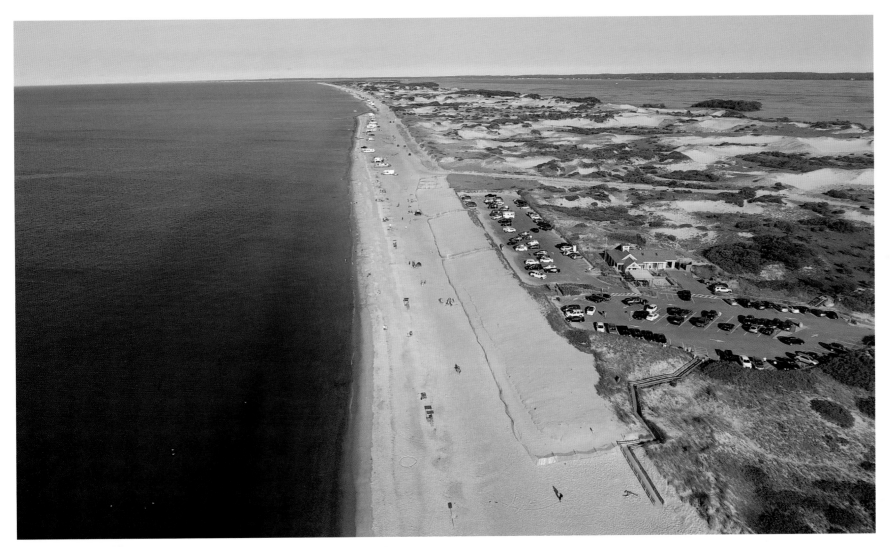

Sandy Neck, Barnstable

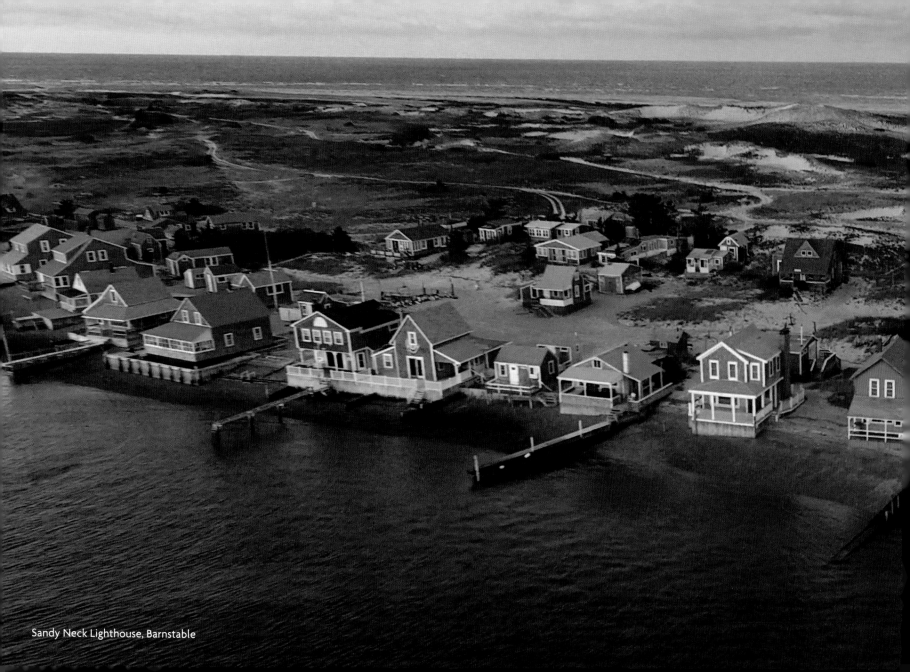

Sandy Neck Lighthouse, Barnstable

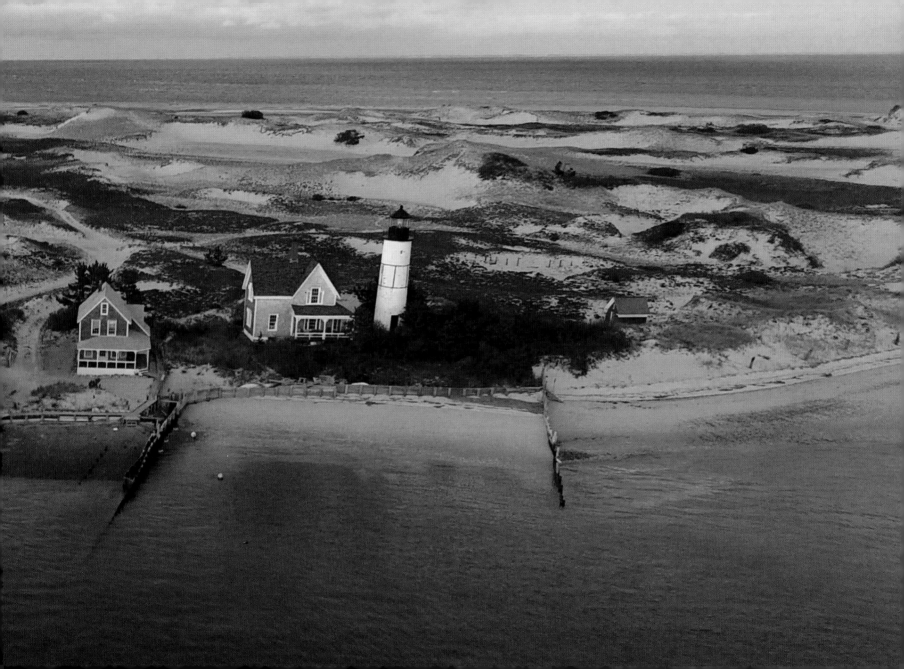

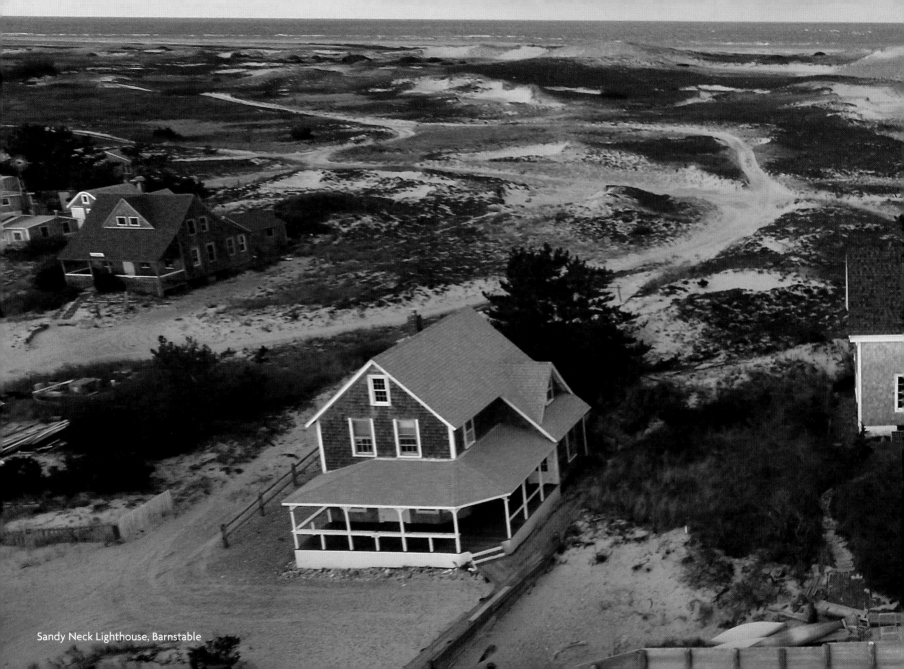

Sandy Neck Lighthouse, Barnstable

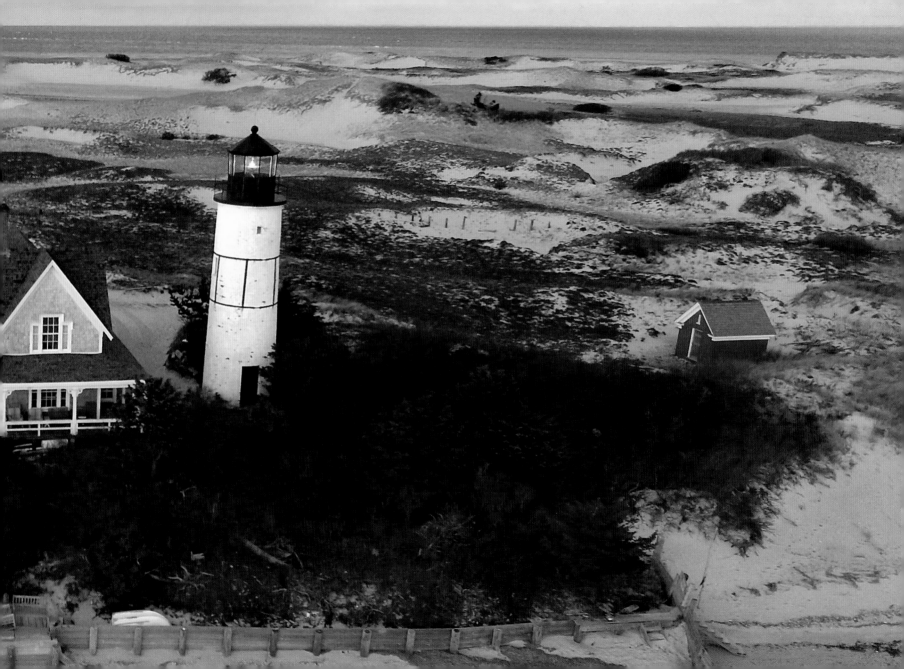

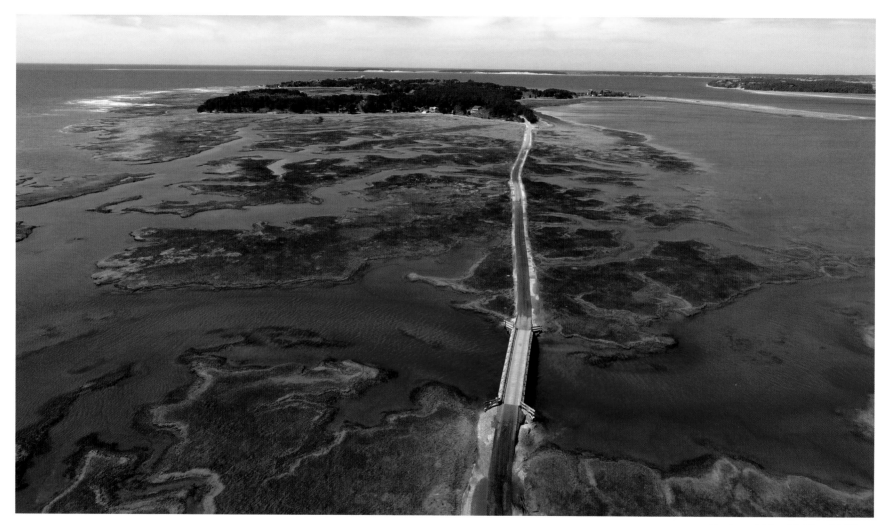

Lieutenant Island Bridge, Wellfleet

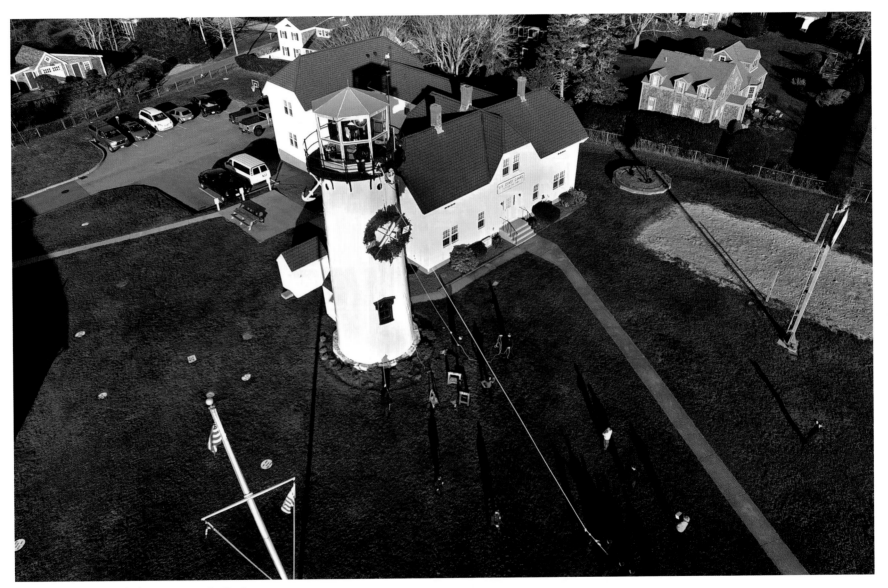

Raising the Coast Guard Christmas wreath, Chatham

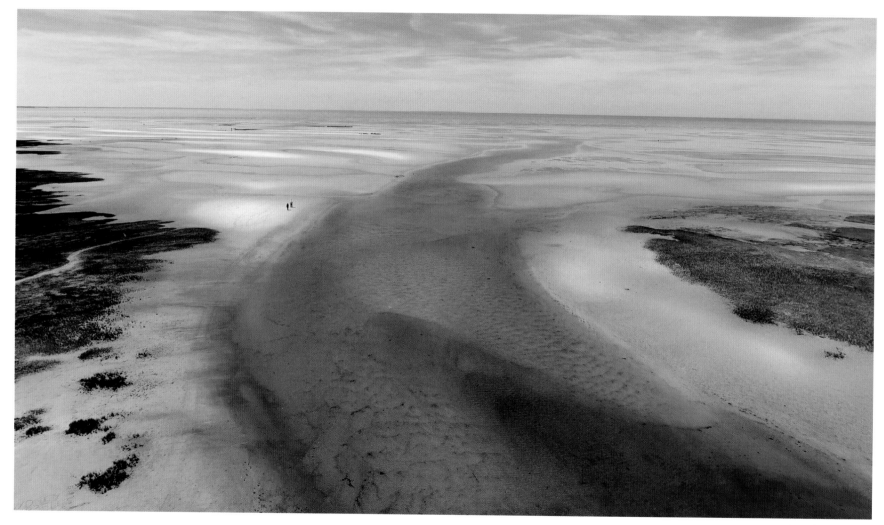

Rock Harbor, Orleans

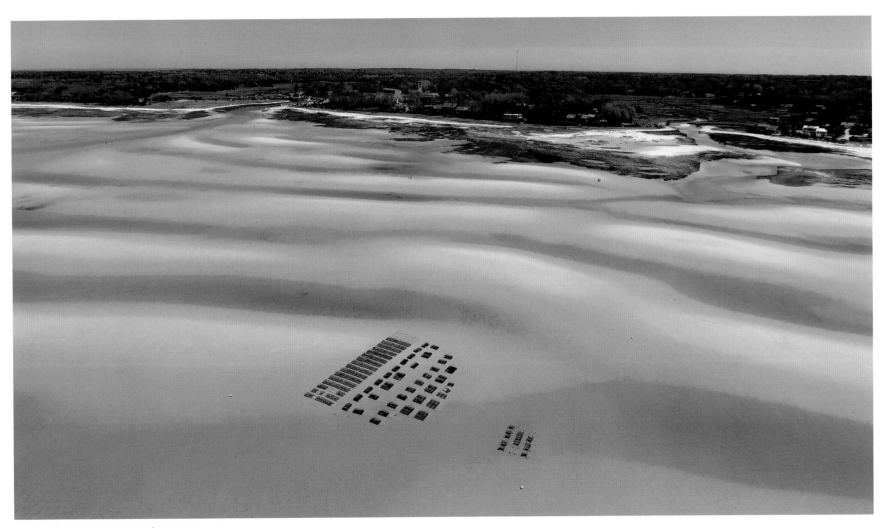

Rock Harbor oyster traps, Orleans

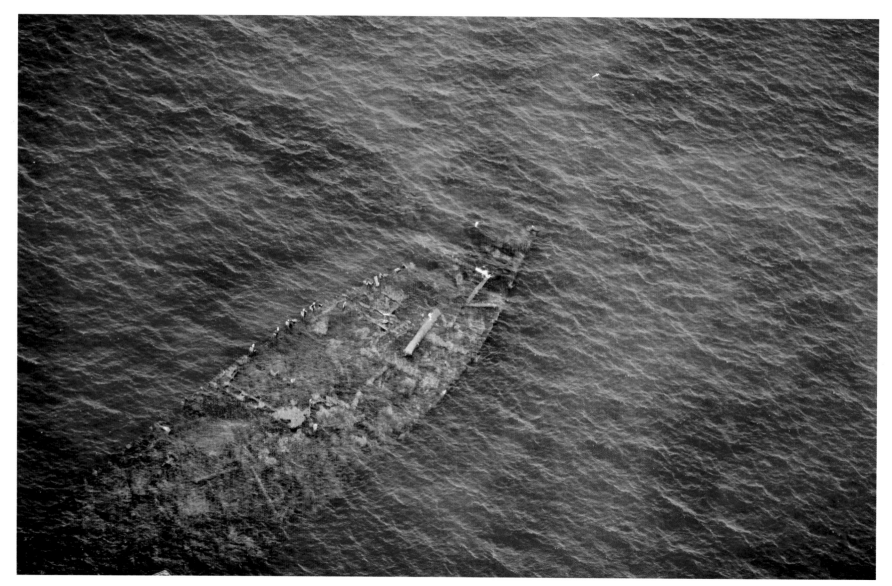

SS James Longstreet, Cape Cod Bay

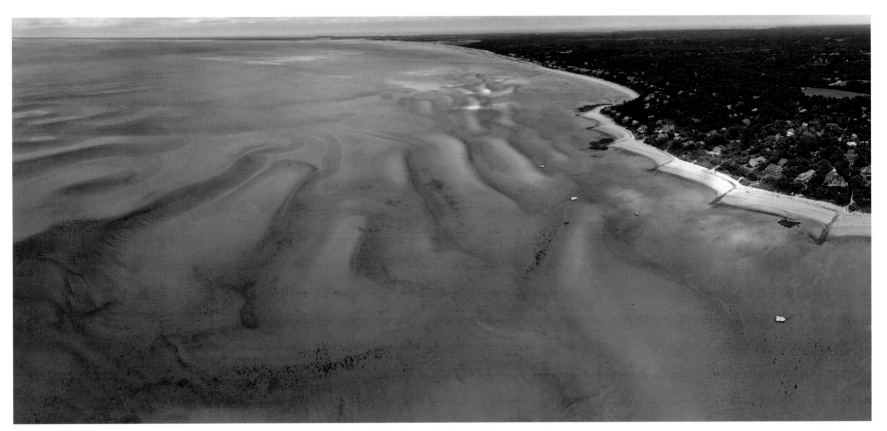

Cape Cod Bay, Brewster

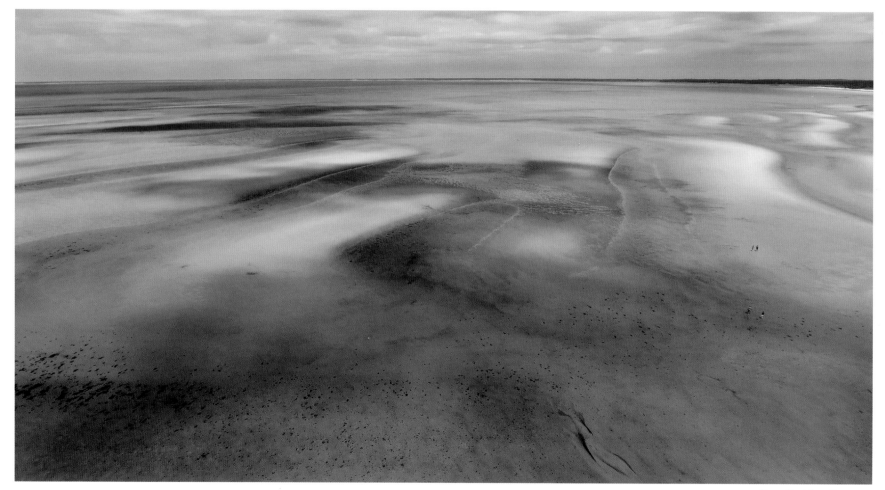

Cape Cod Bay, Brewster

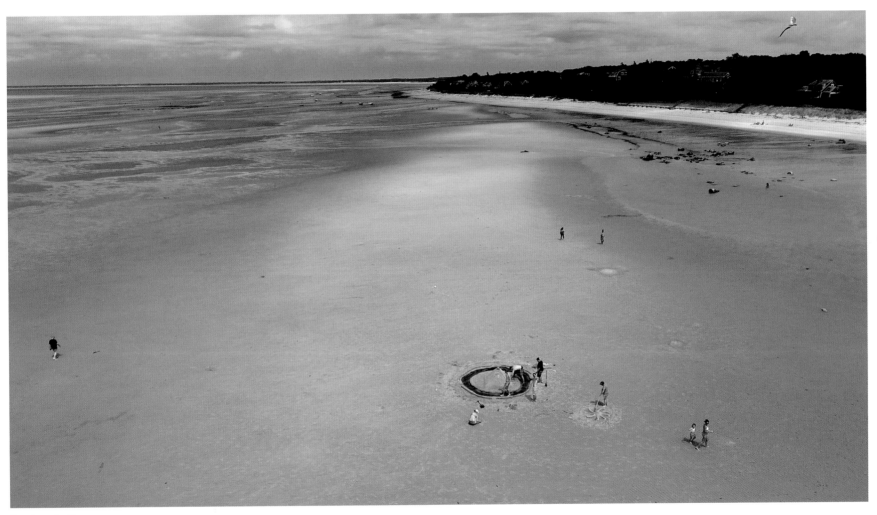

Sand castle, Brewster

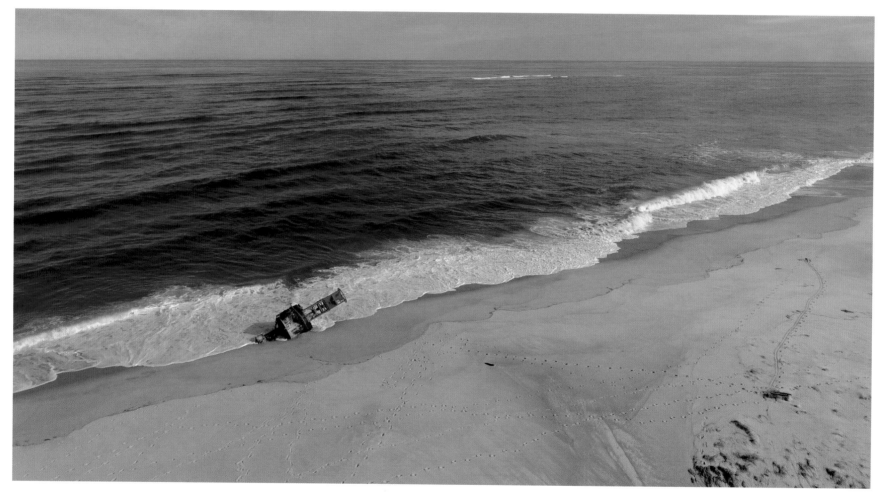

Buoy aground on South Beach Island, Chatham

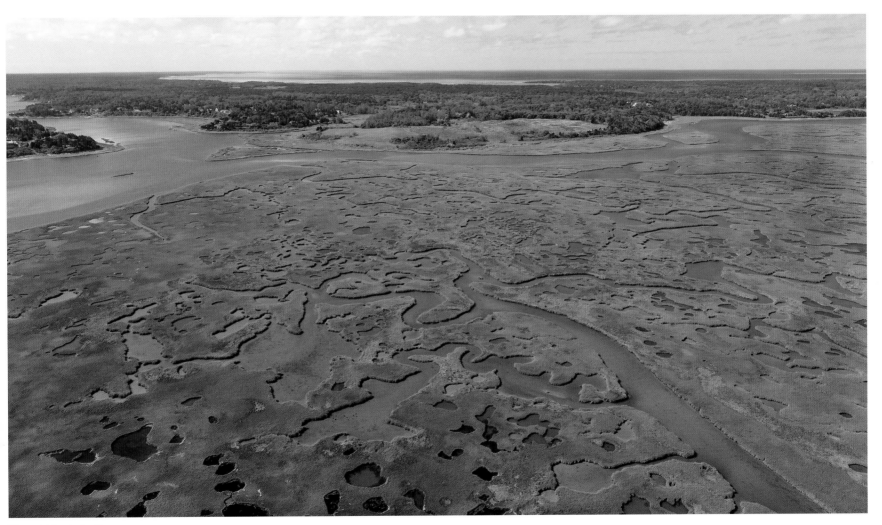

Nauset Marsh, Eastham

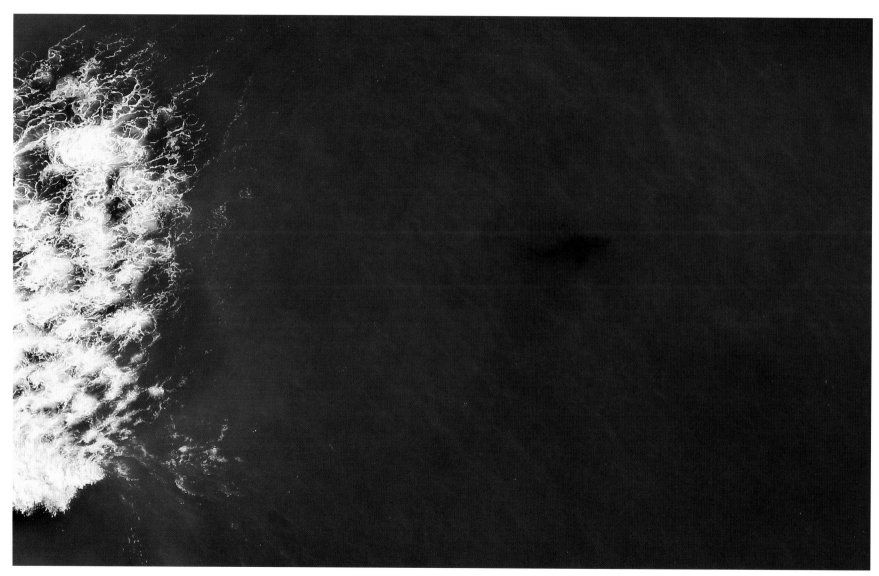

Great white shark, South Beach Island, Chatham

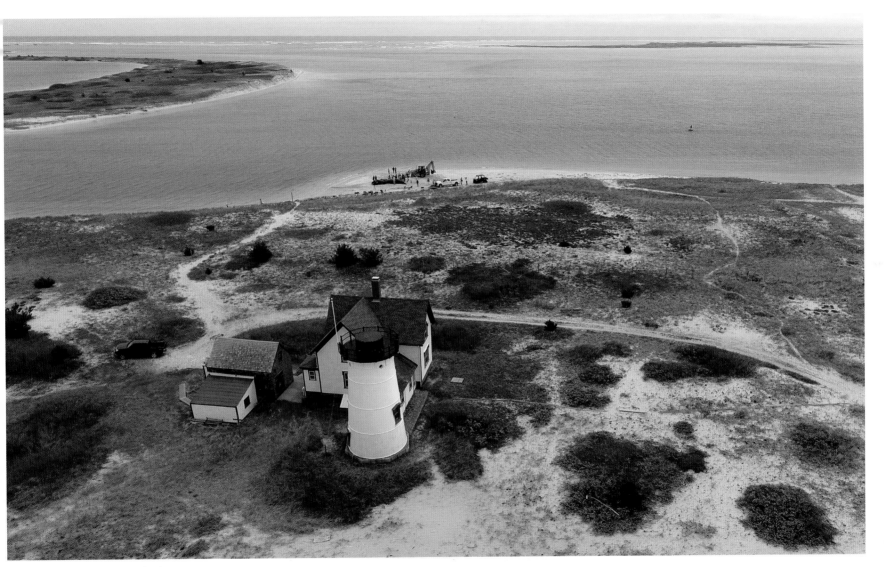

Baby right whale necropsy, Chatham

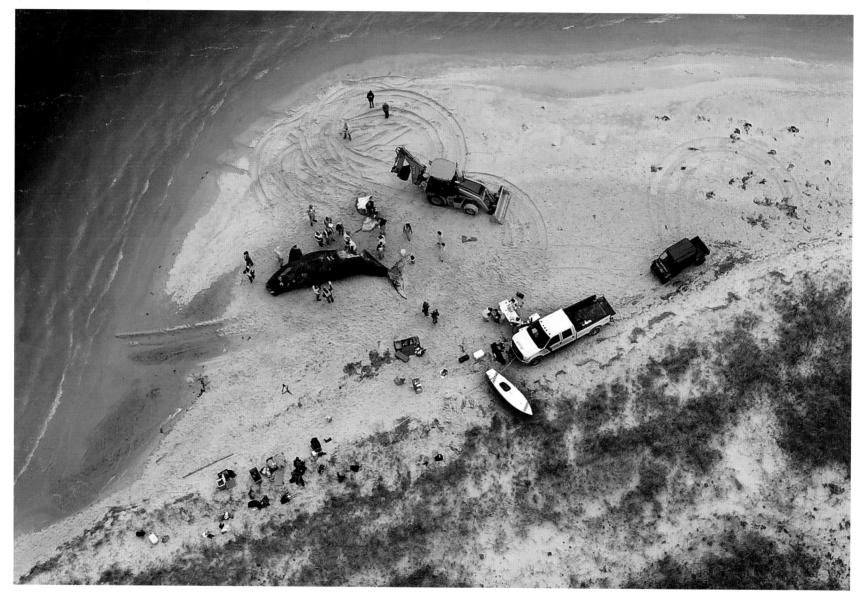

Baby right whale necropsy, Chatham

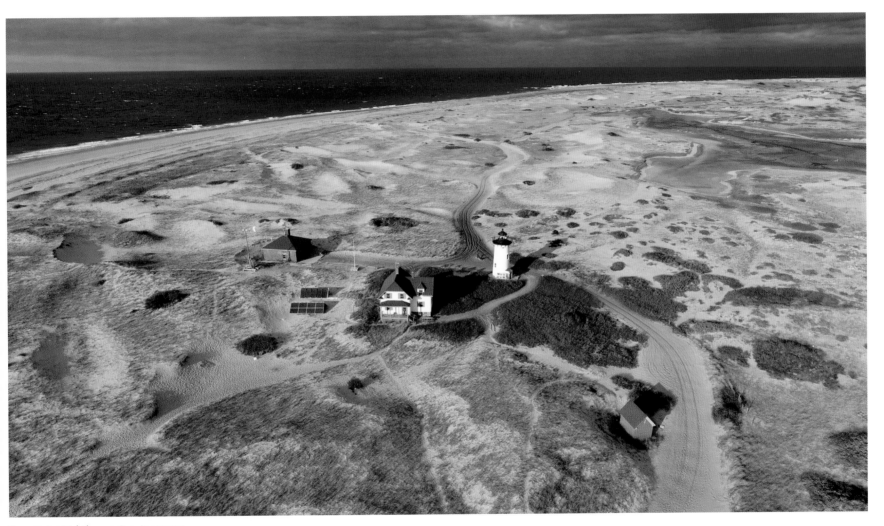

Race Point Lighthouse, Provincetown

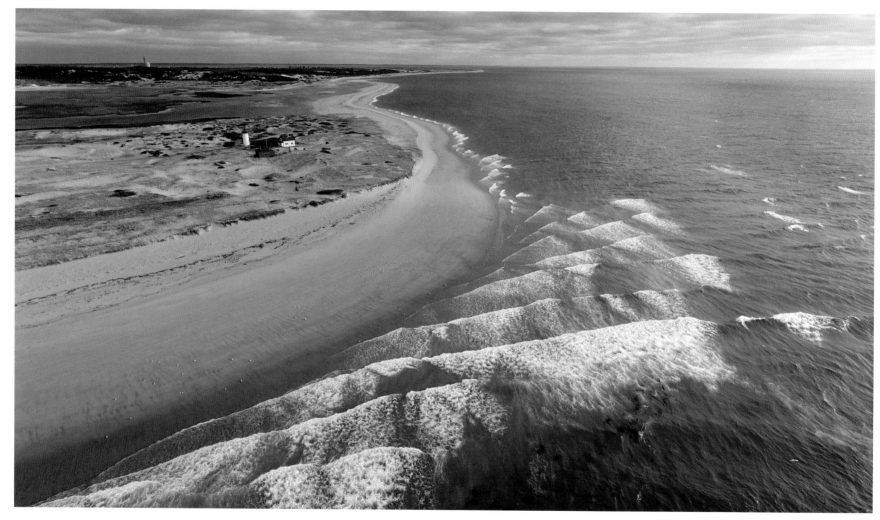

Race Point Lighthouse, Provincetown

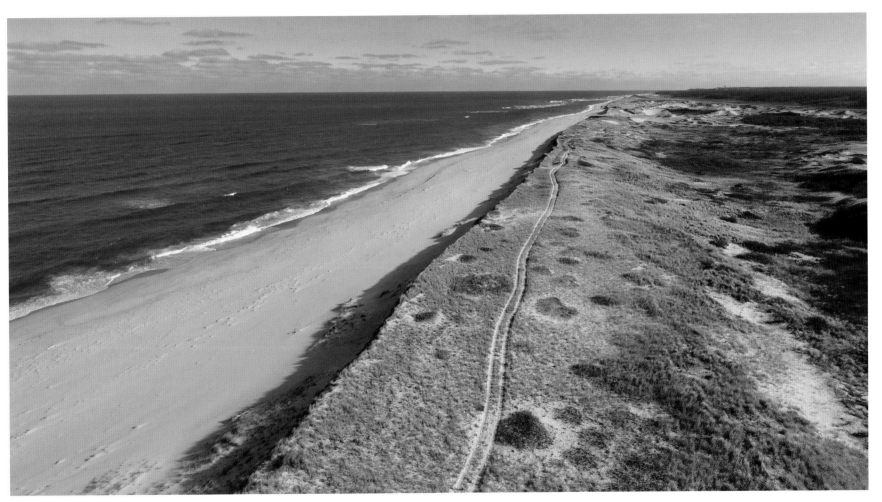

Cape Cod National Seashore, Provincetown

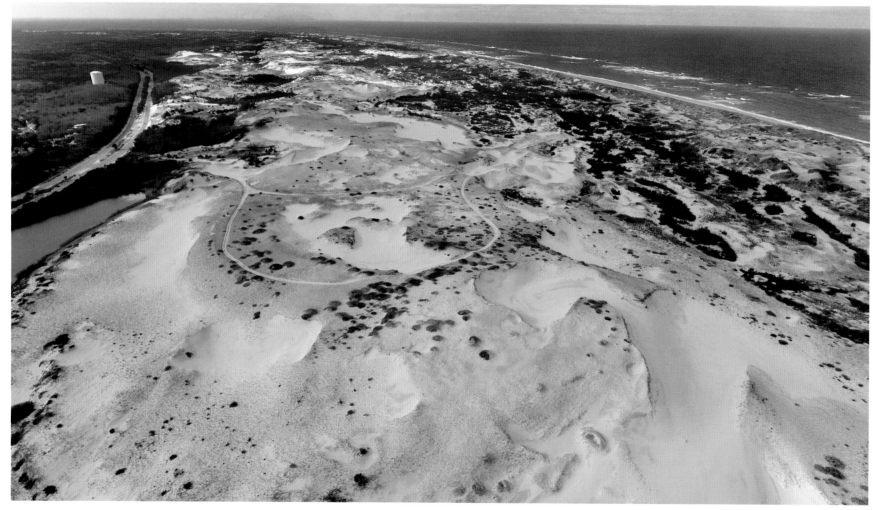

Fire road into the dunes, Truro

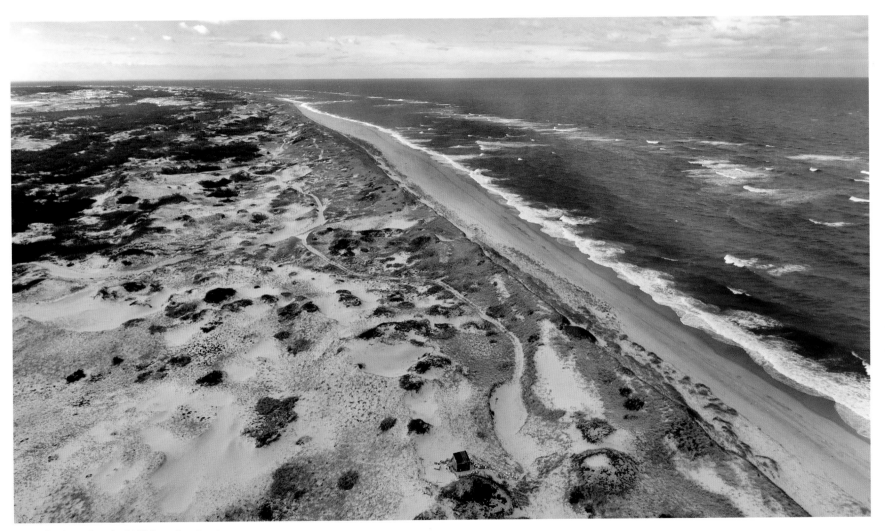

Dune shacks and Peaked Hill Bars, Provincetown

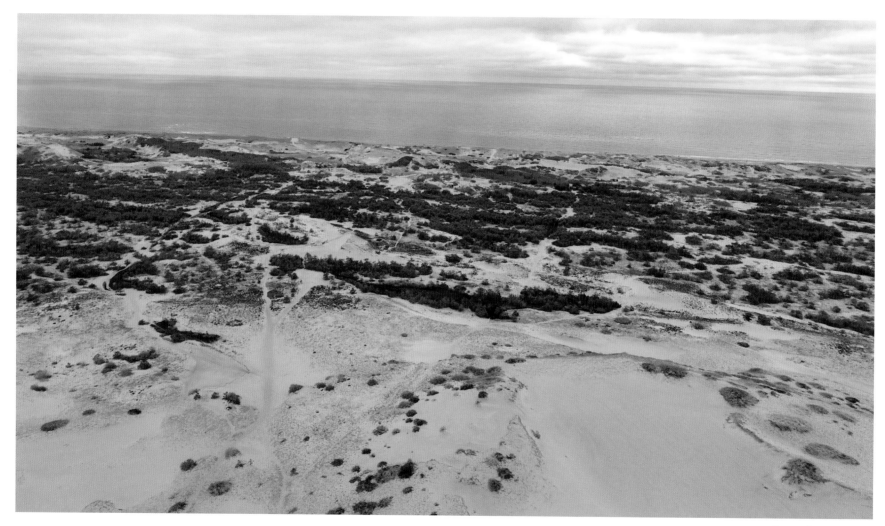

Dunes, Provincetown

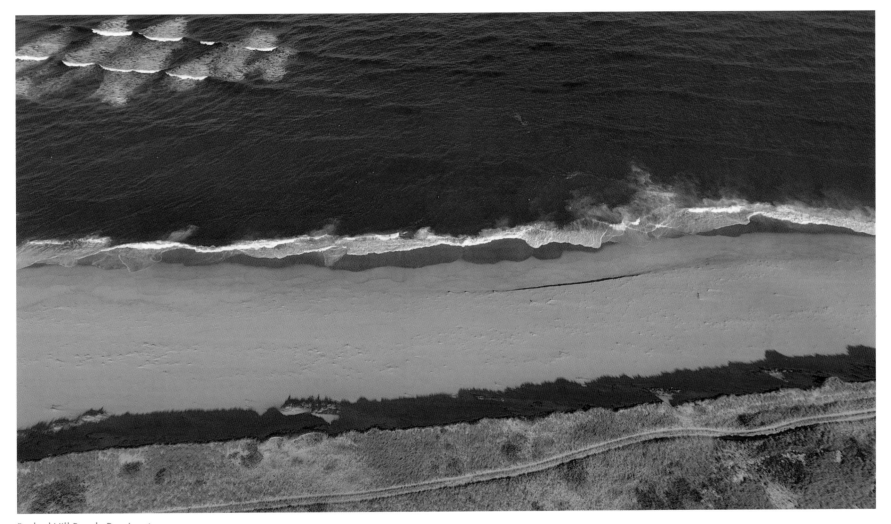

Peaked Hill Beach, Provincetown

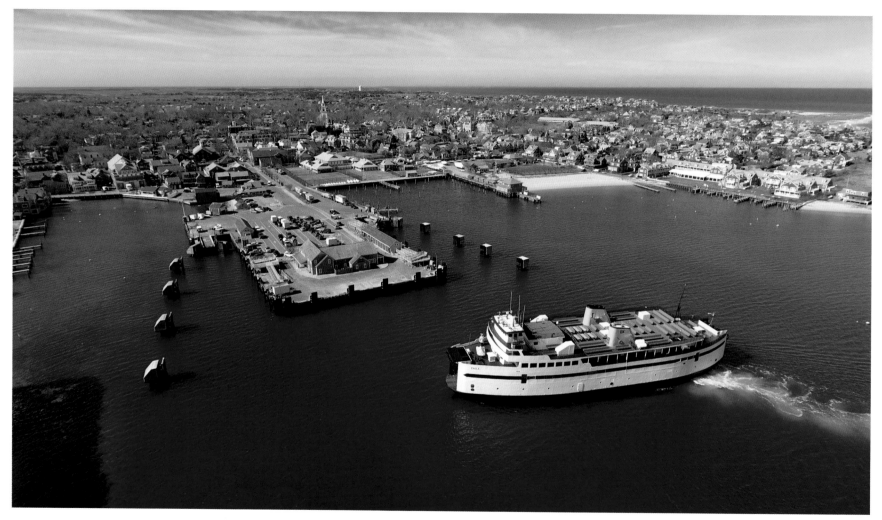

Nantucket Ferry, Nantucket

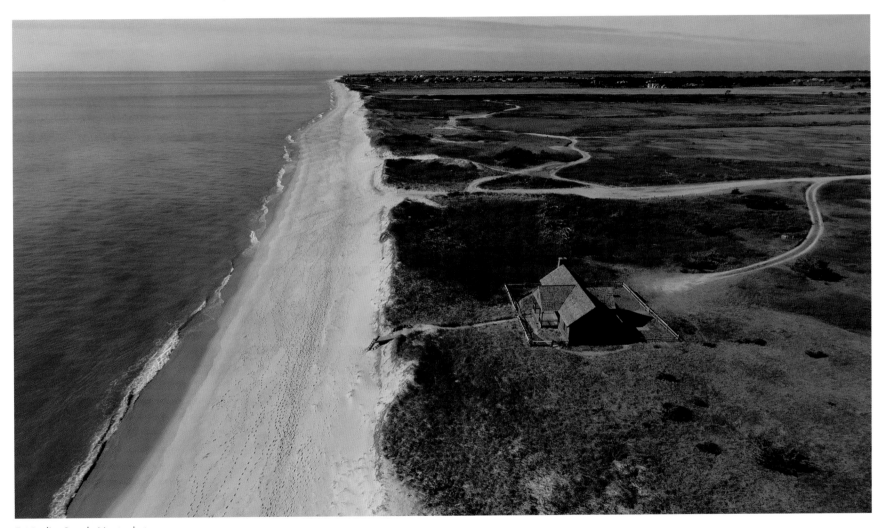

Fat Ladies Beach, Nantucket

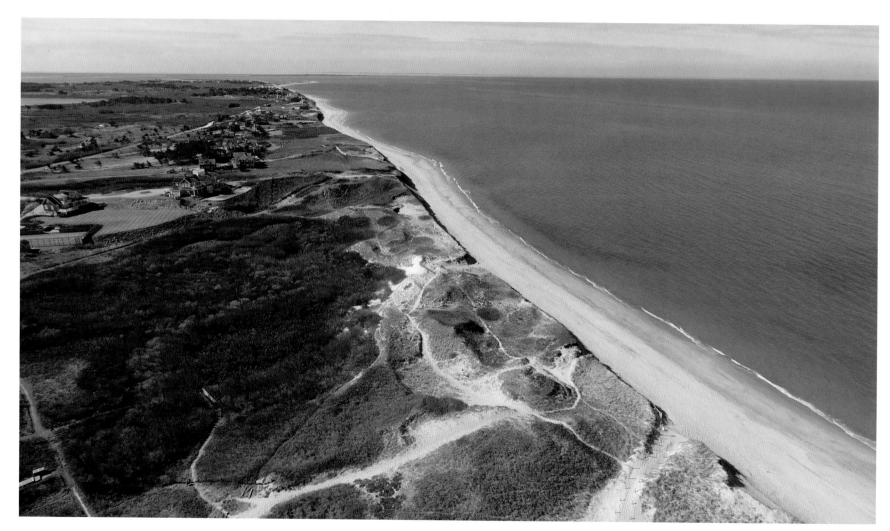

Dionis Beach, Nantucket

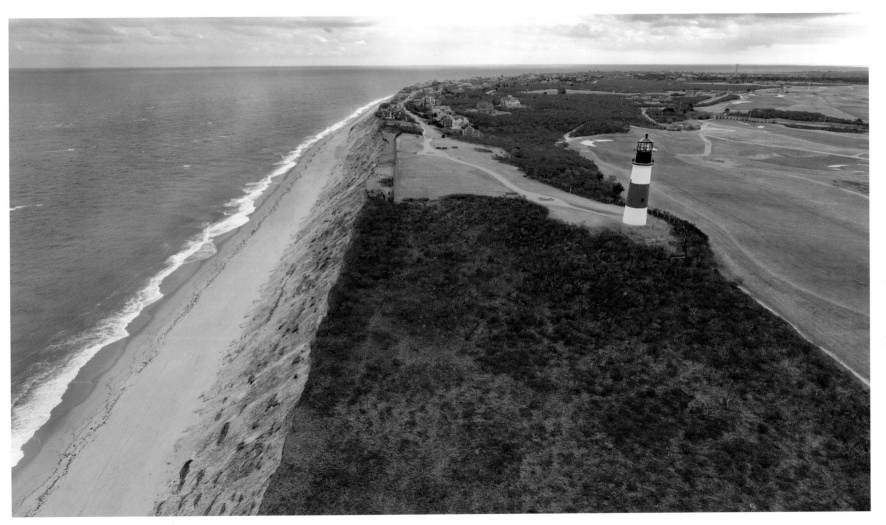

Sankaty Head Lighthouse, Nantucket

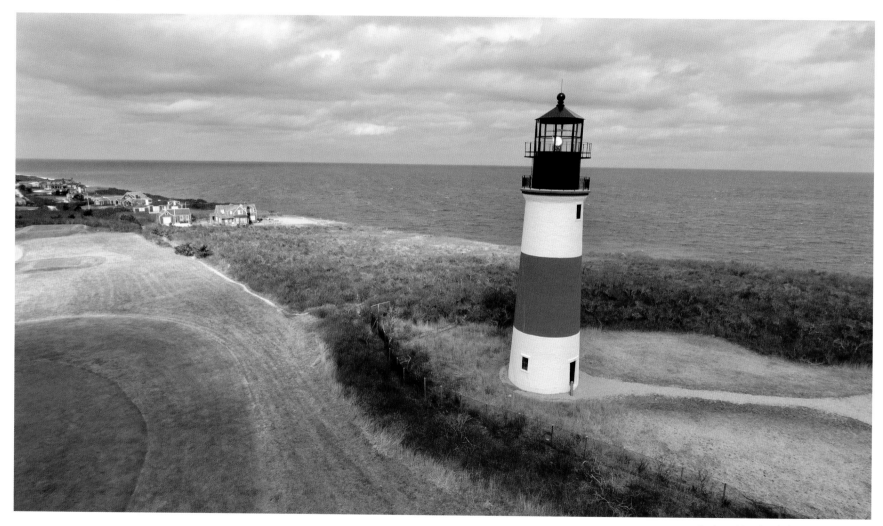

Sankaty Head Lighthouse, Nantucket

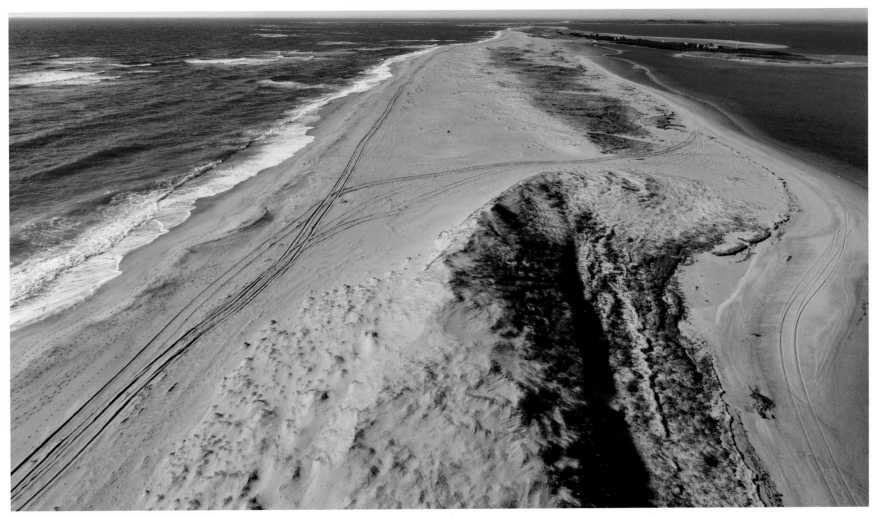

Esther's Island, Nantucket

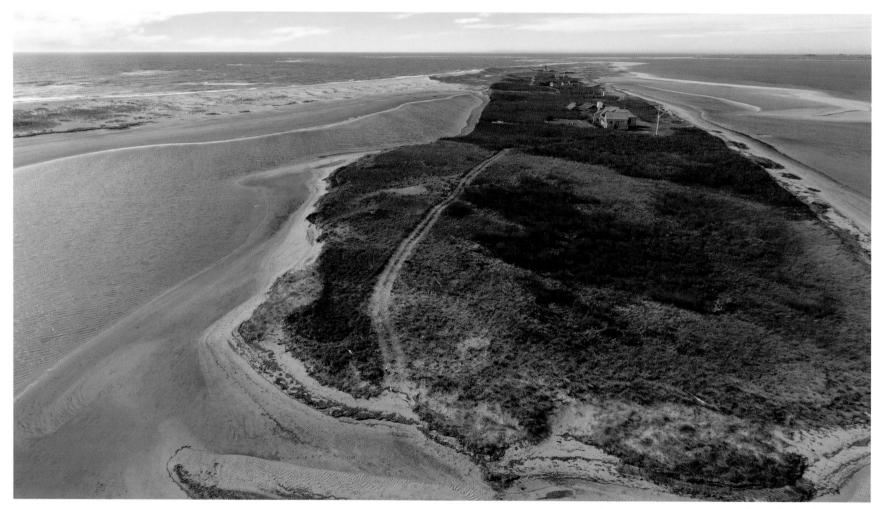

Tuckernuck Island, Nantucket

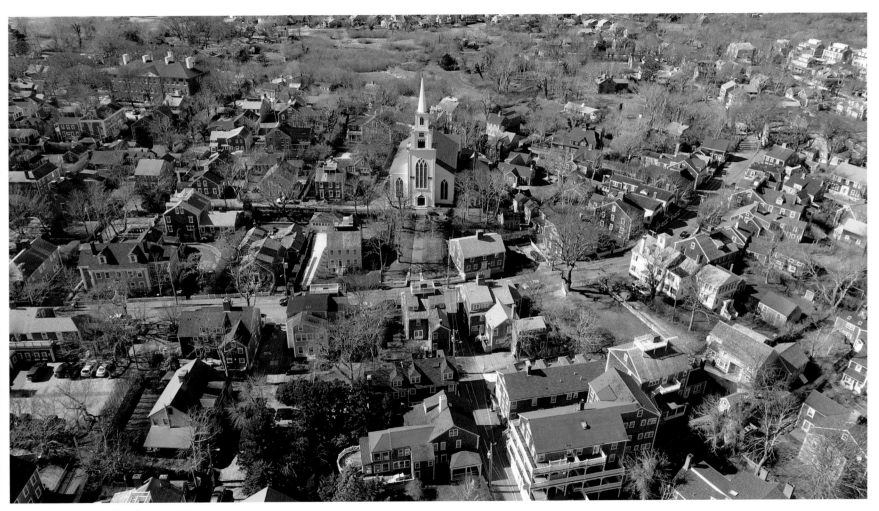

First Congregational Church, Nantucket

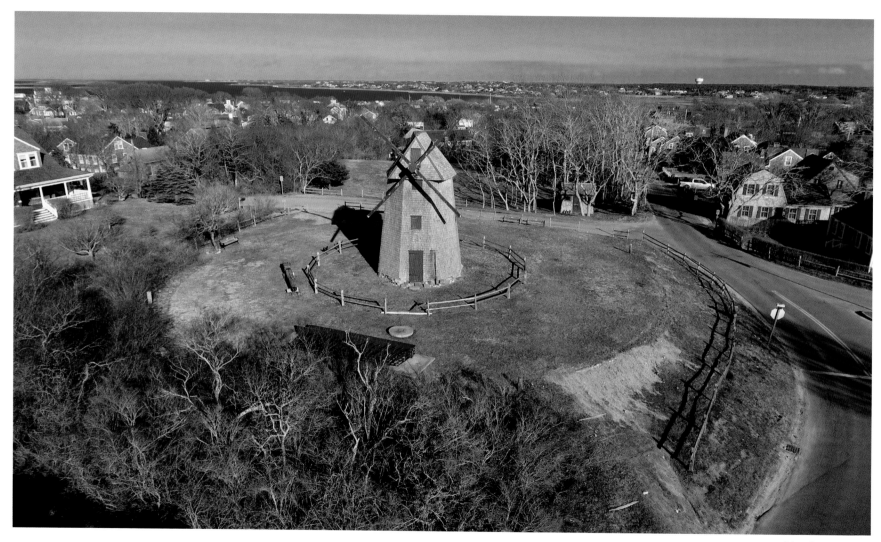

Old Mill, Nantucket

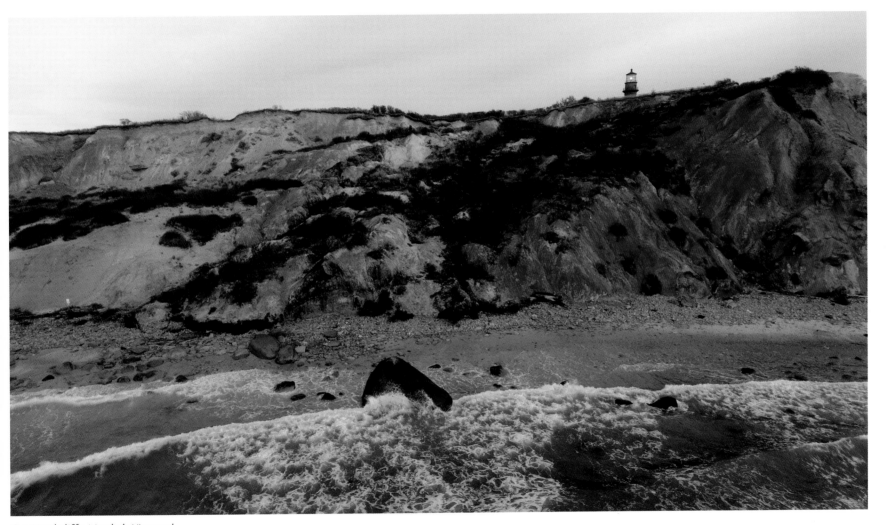

Gay Head cliffs, Martha's Vineyard

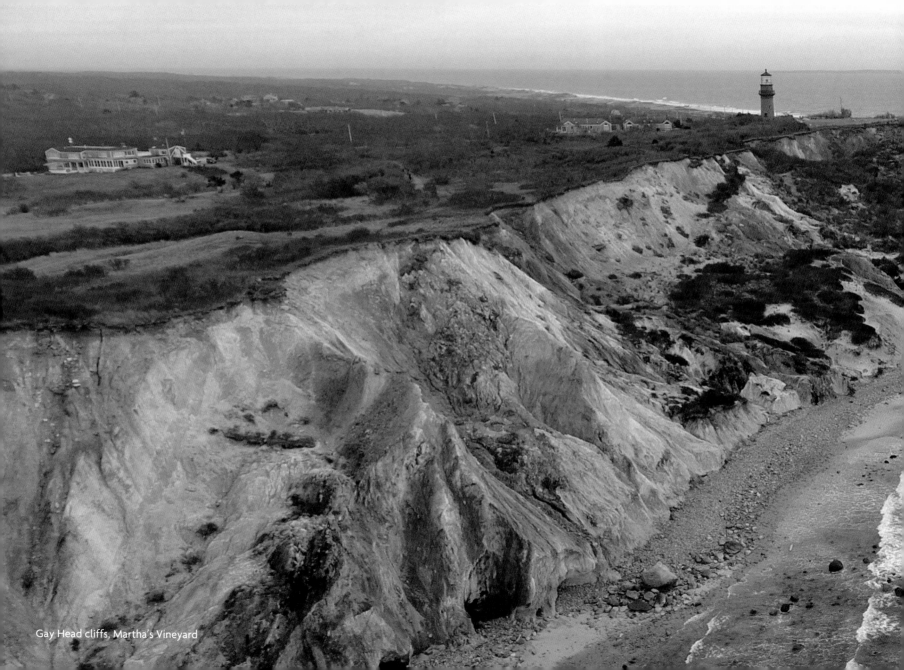

Gay Head cliffs, Martha's Vineyard

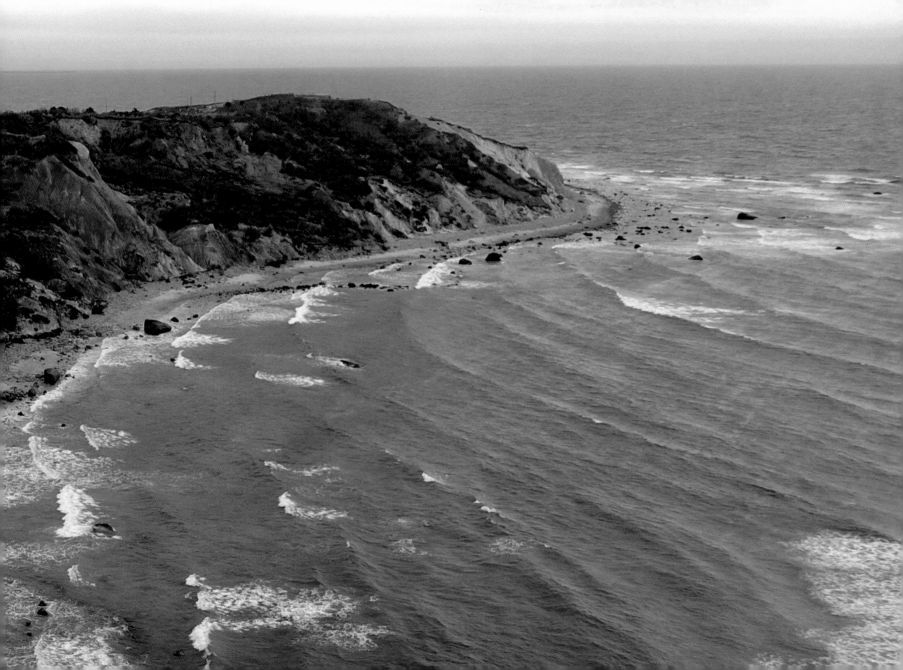

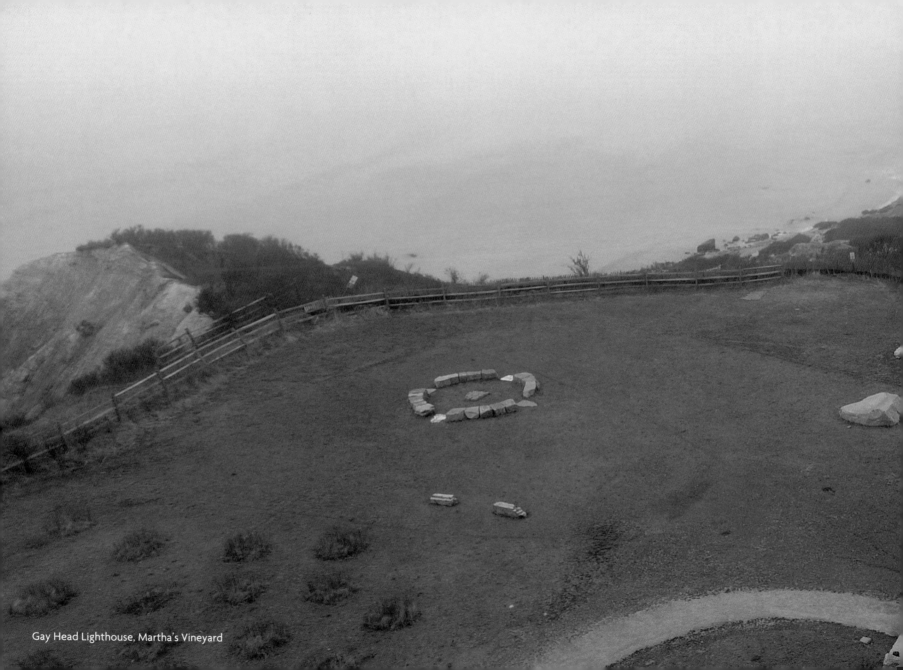

Gay Head Lighthouse, Martha's Vineyard

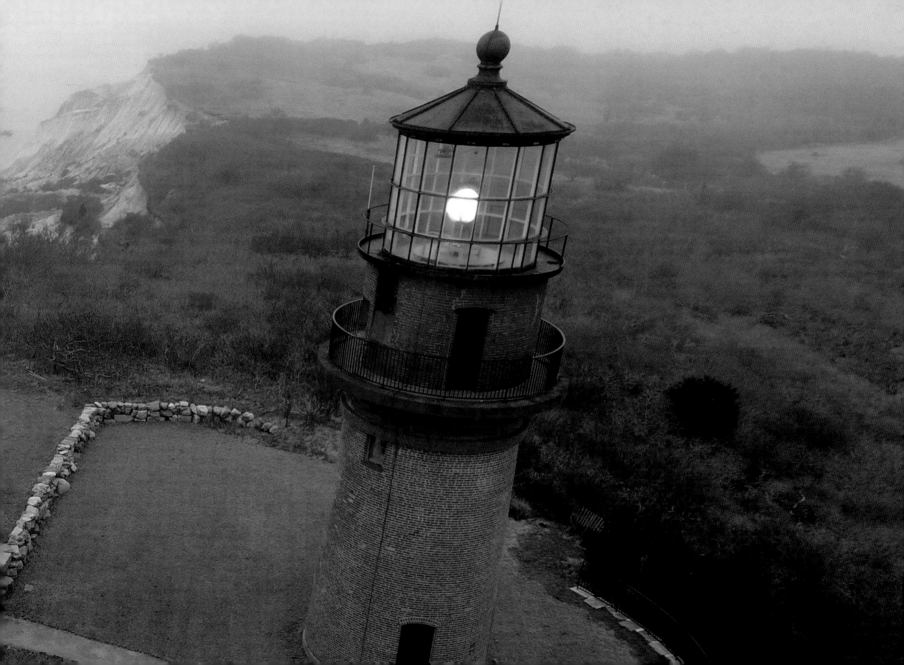

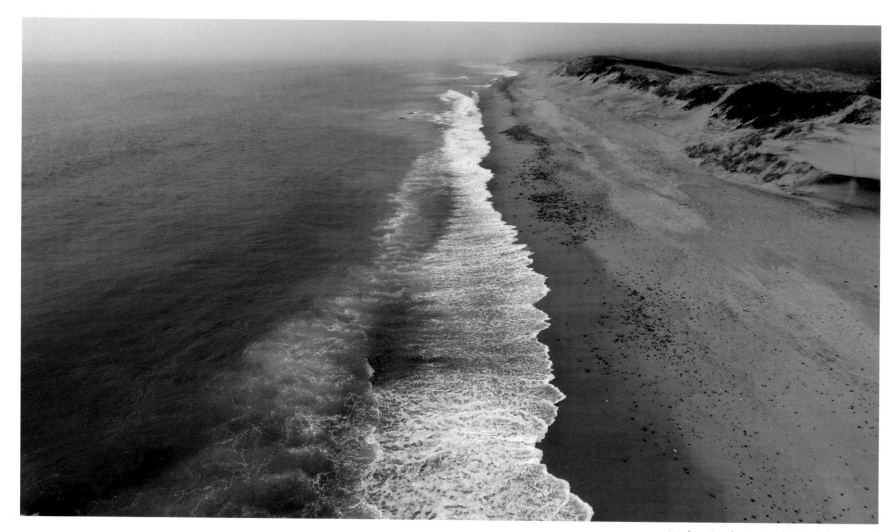

Moshup Beach, Aquinnah, Martha's Vineyard

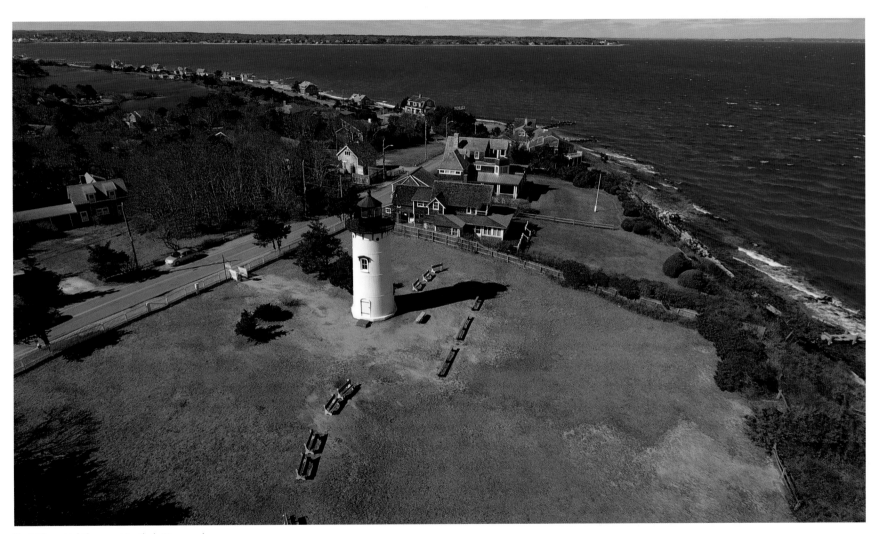

East Chop Lighthouse, Martha's Vineyard

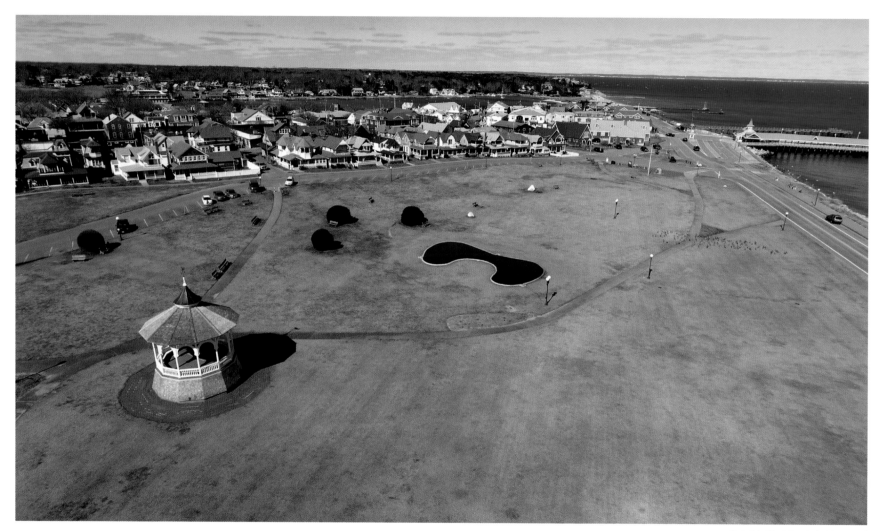

Oak Bluffs, Martha's Vineyard

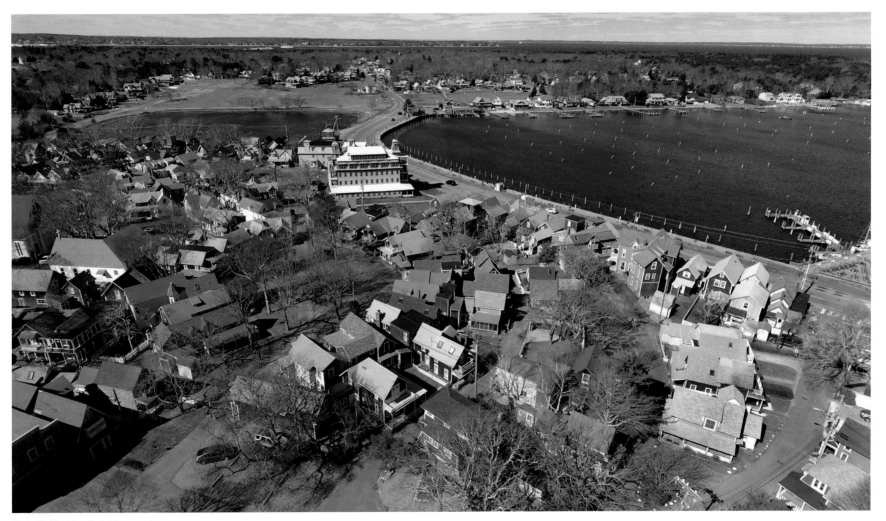

Oak Bluffs, Martha's Vineyard

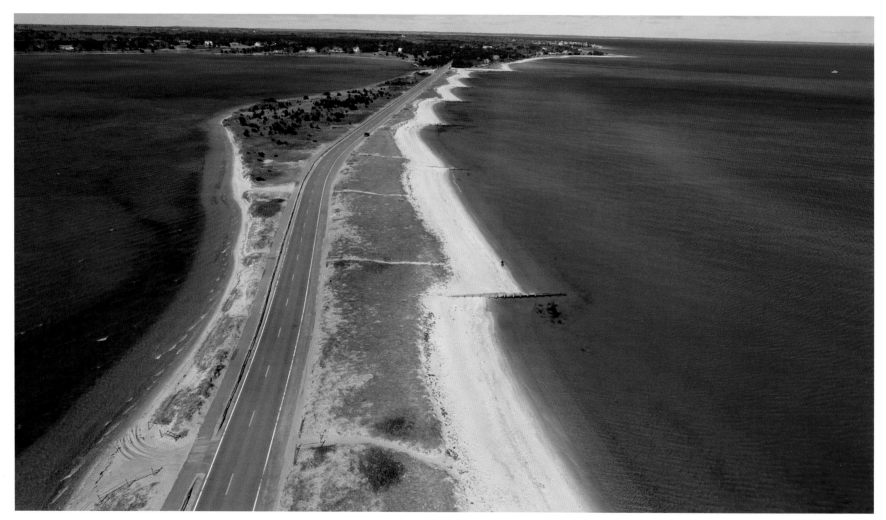

Joseph Sylvia State Beach, Martha's Vineyard

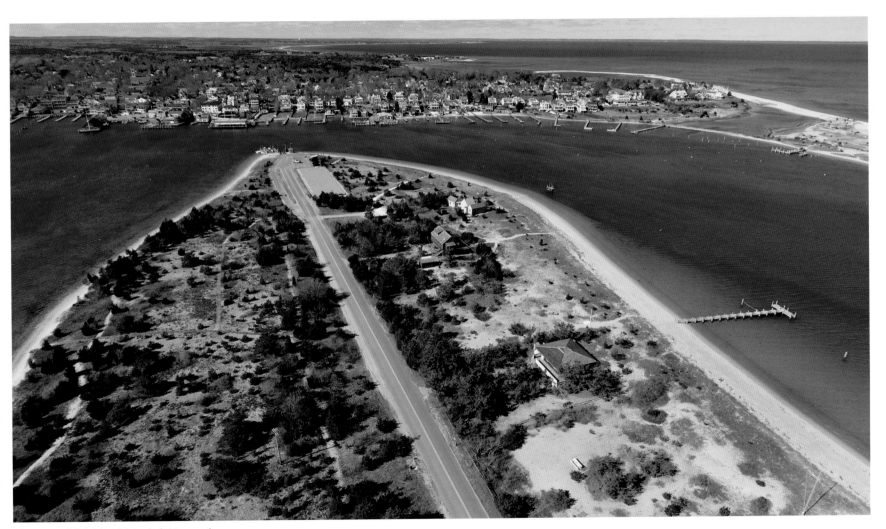

Chappaquiddick Island, Martha's Vineyard

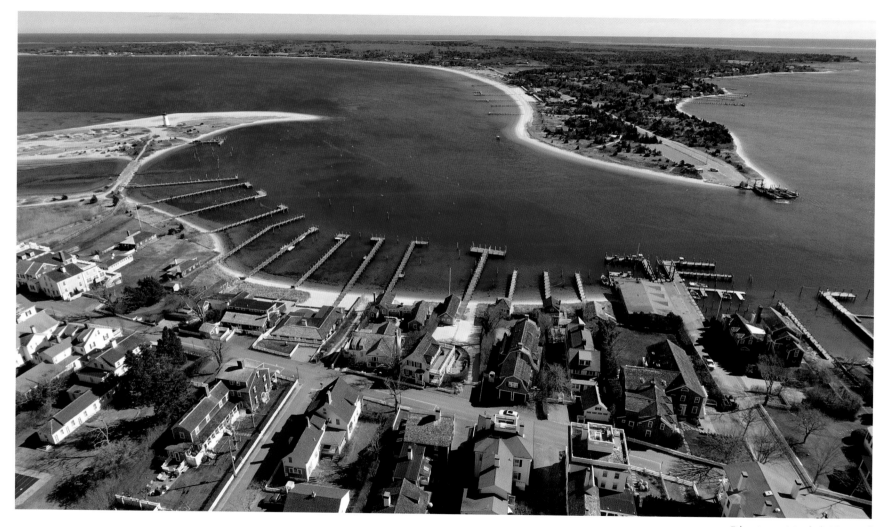

Edgartown, Martha's Vineyard

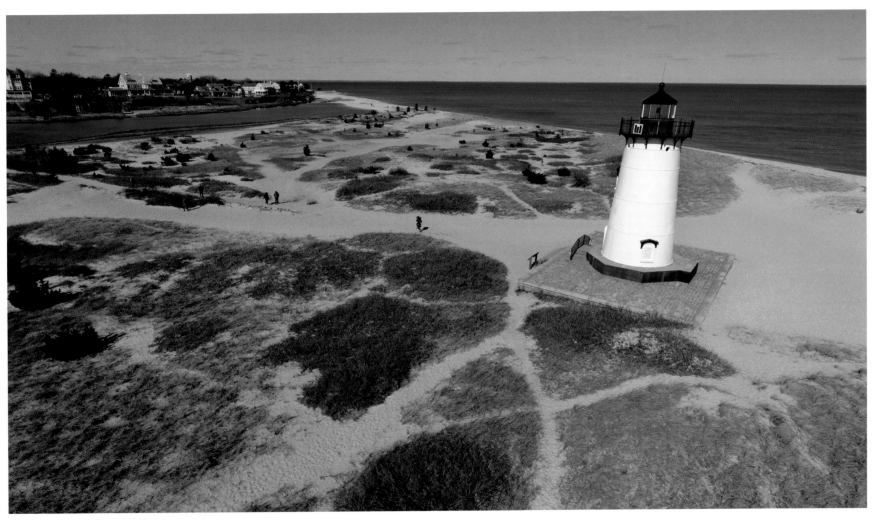

Edgartown Lighthouse, Martha's Vineyard

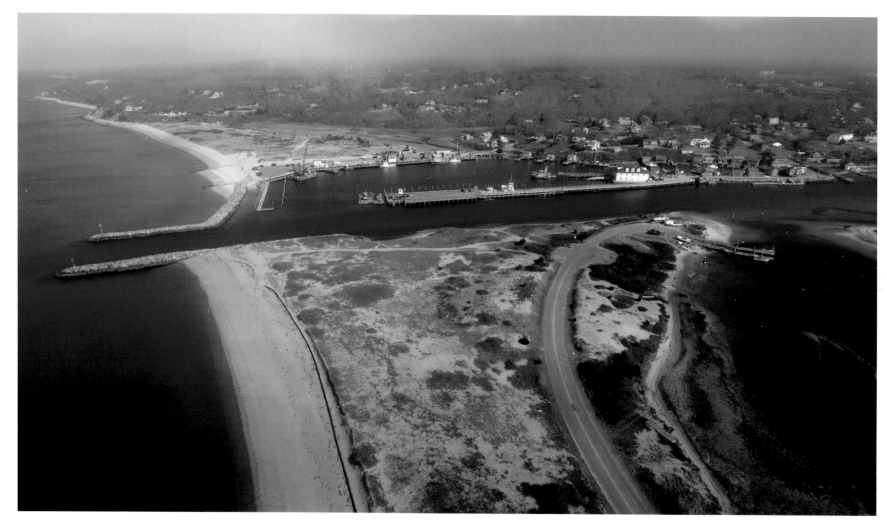

Menemsha Harbor, Martha's Vineyard

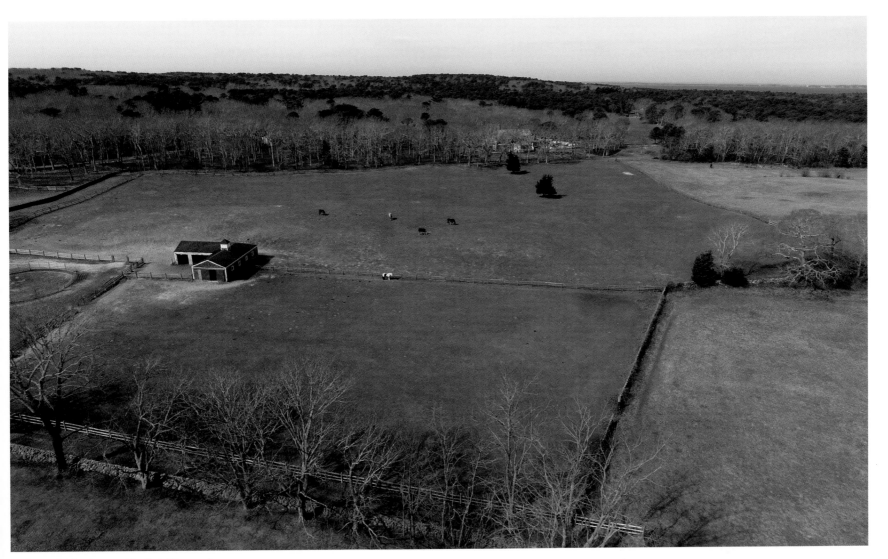

Tashmoo Spring horses, Martha's Vineyard

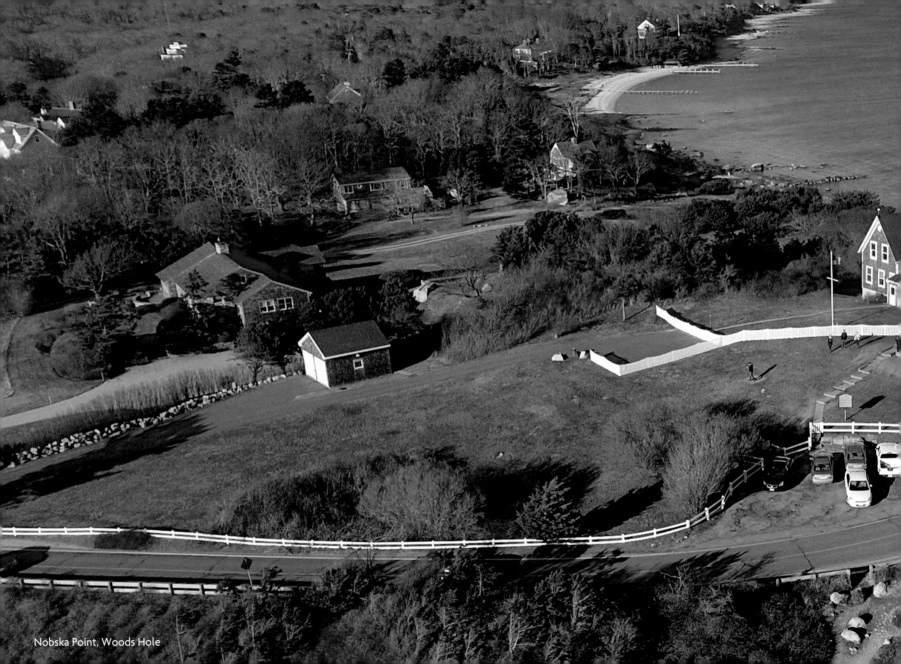
Nobska Point, Woods Hole

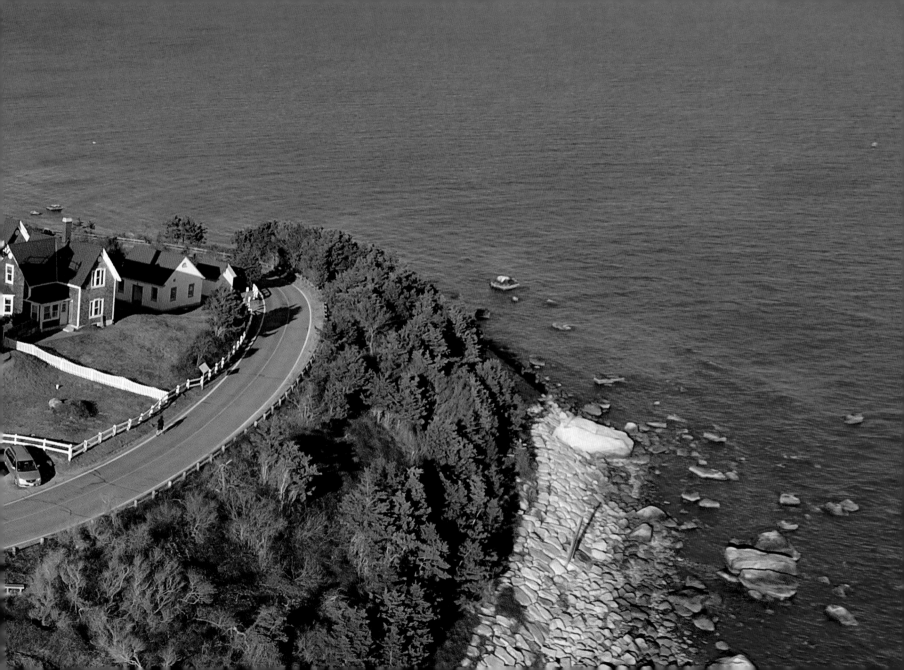

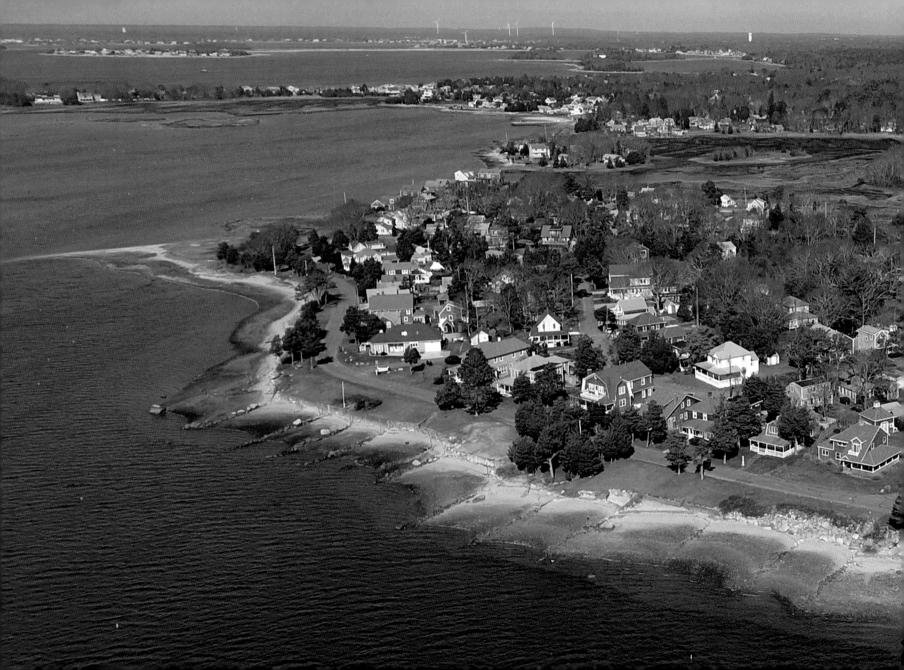

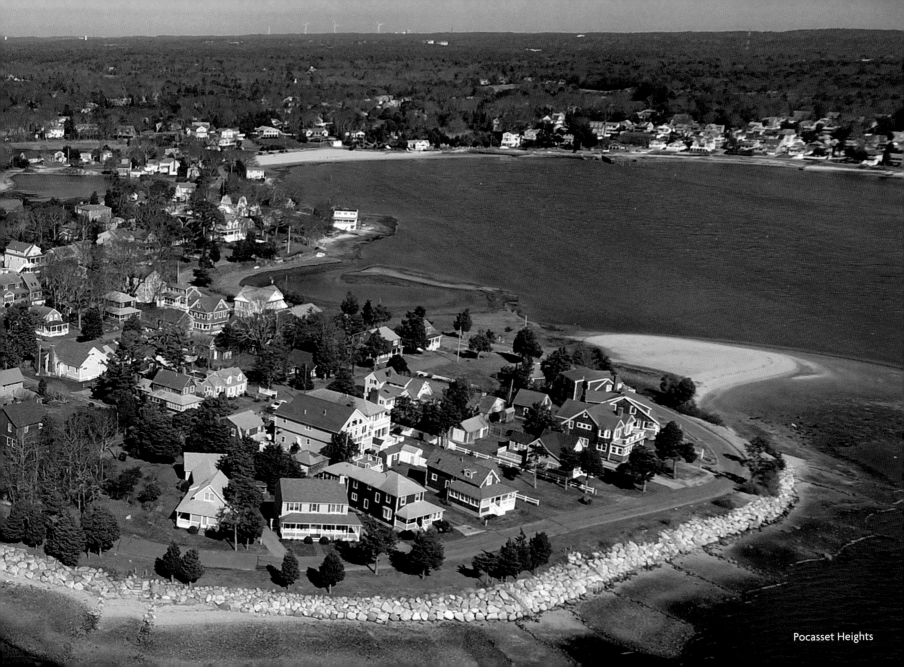
Pocasset Heights

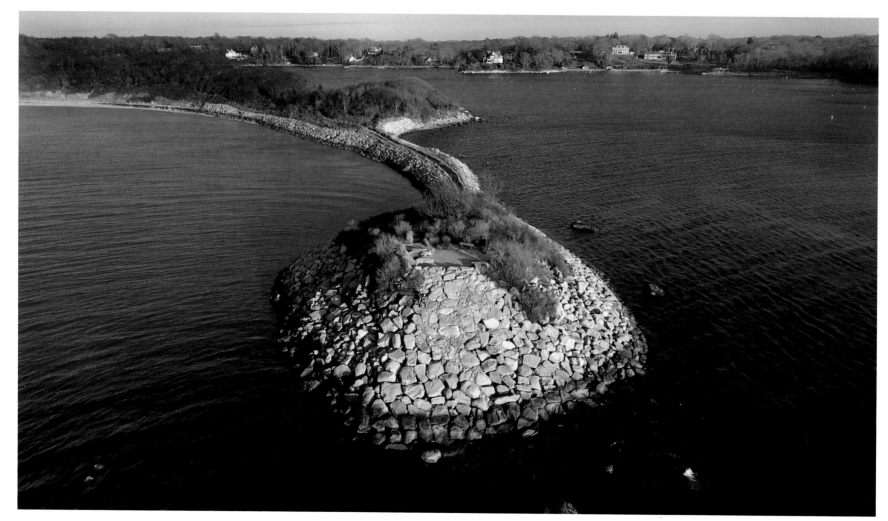

The Knob, Woods Hole

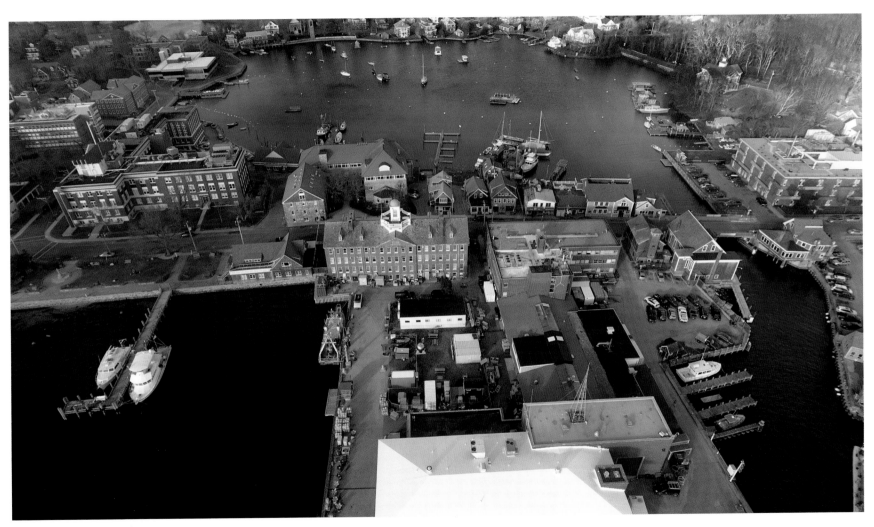

Woods Hole Oceanographic Institution

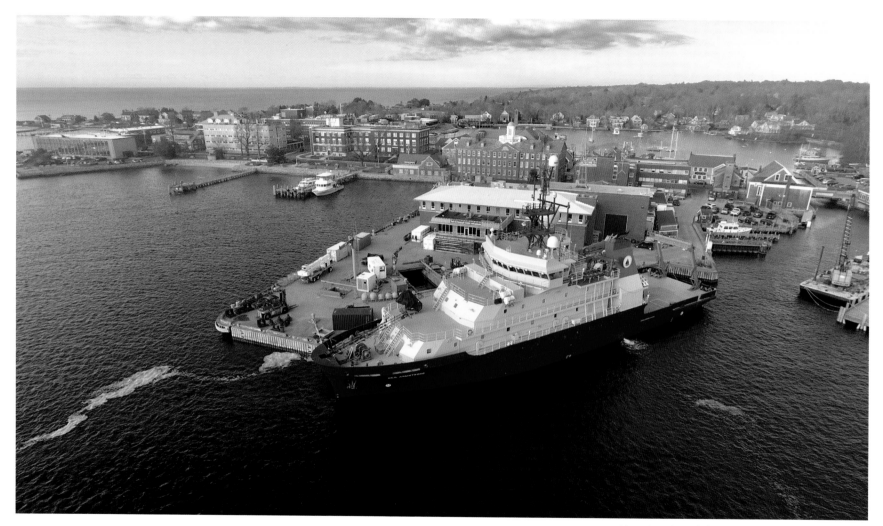

Woods Hole and the research vessel *Neal Armstrong*

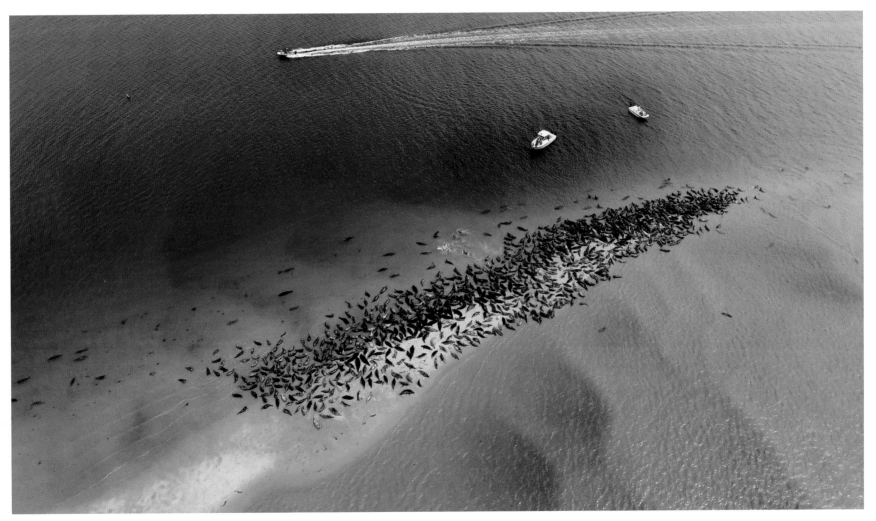

Grey and harbor seals, Chatham

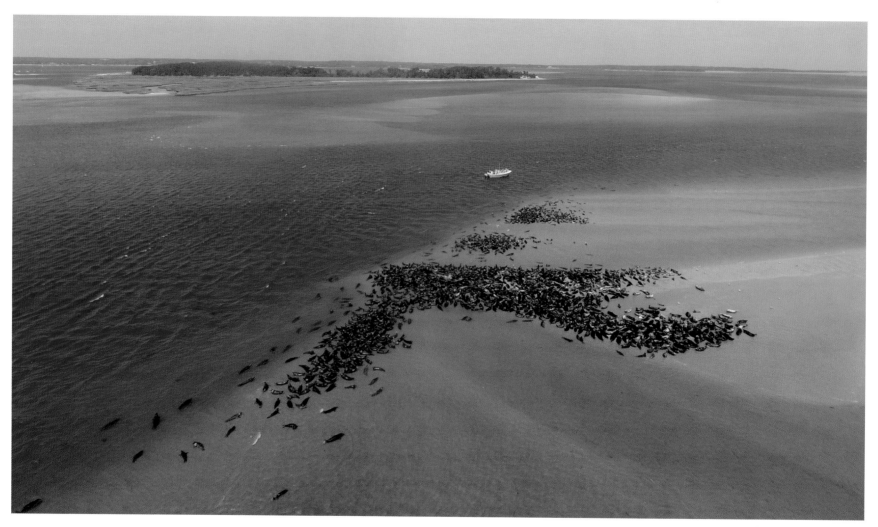

Grey and harbor seals, Chatham

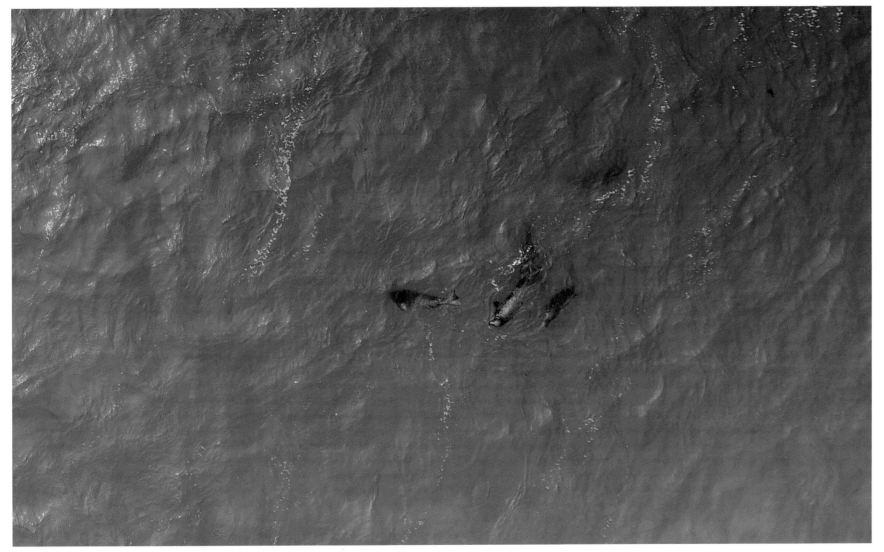

Seals in Pleasant Bay, Orleans

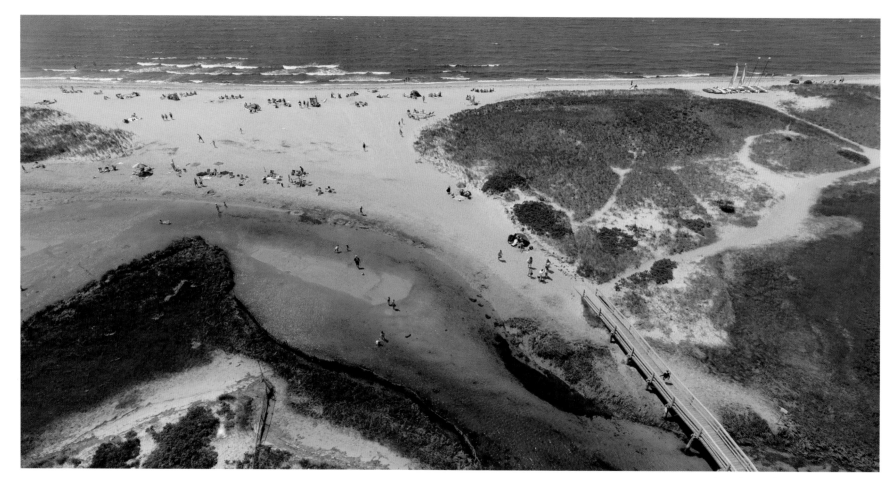

Ridgevale Beach in summer, Chatham

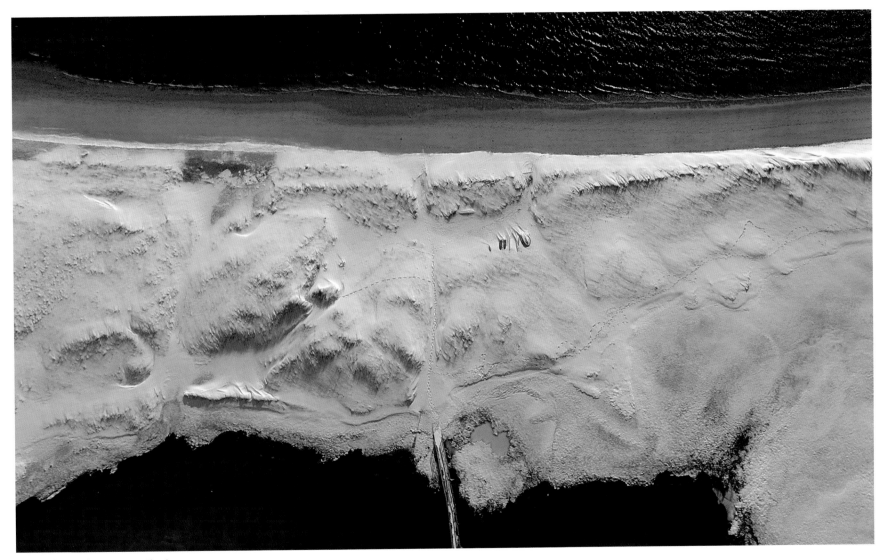

Ridgevale Beach in winter, Chatham

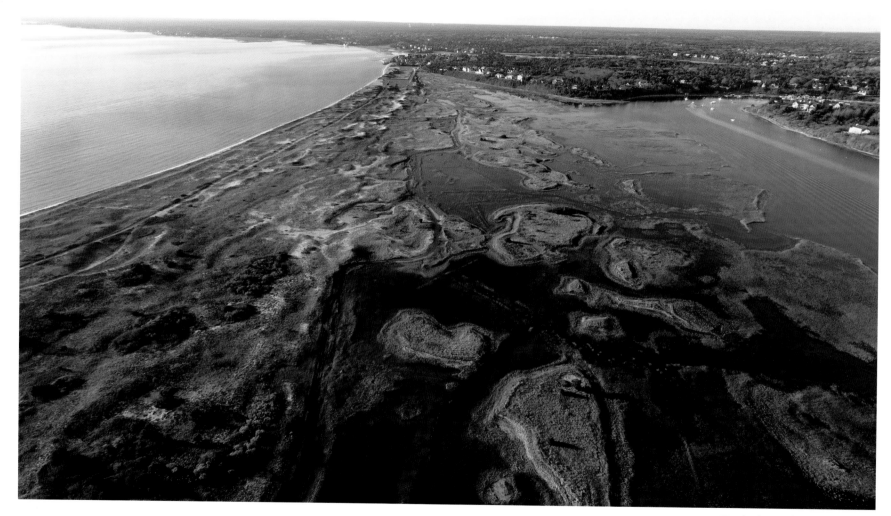

Harding's Beach Marsh, Chatham

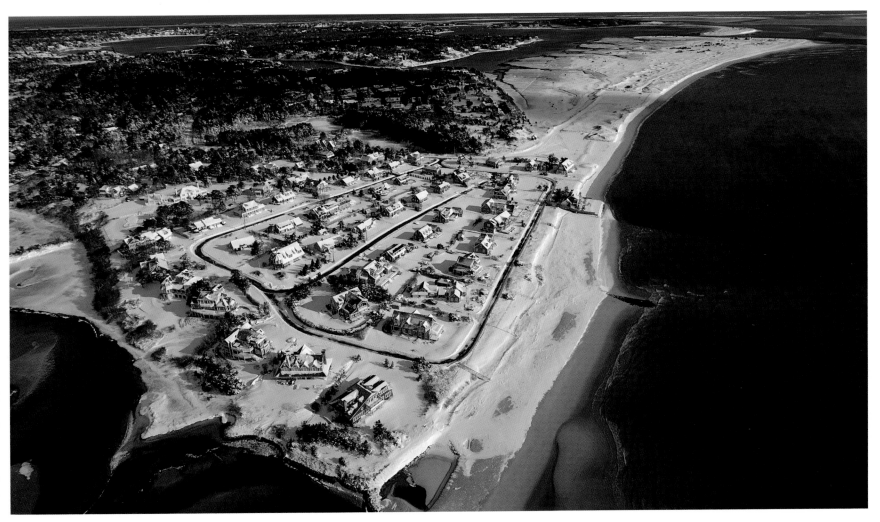

Harding Shores

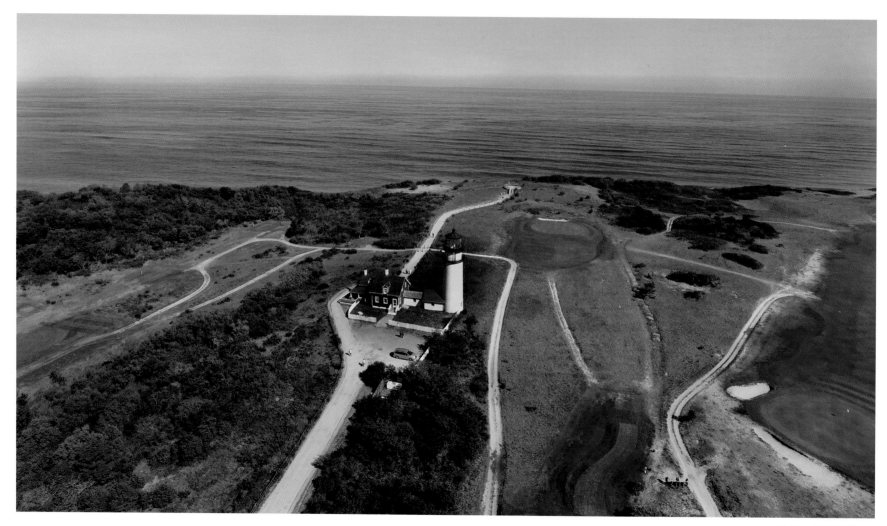

Highland Light, Truro

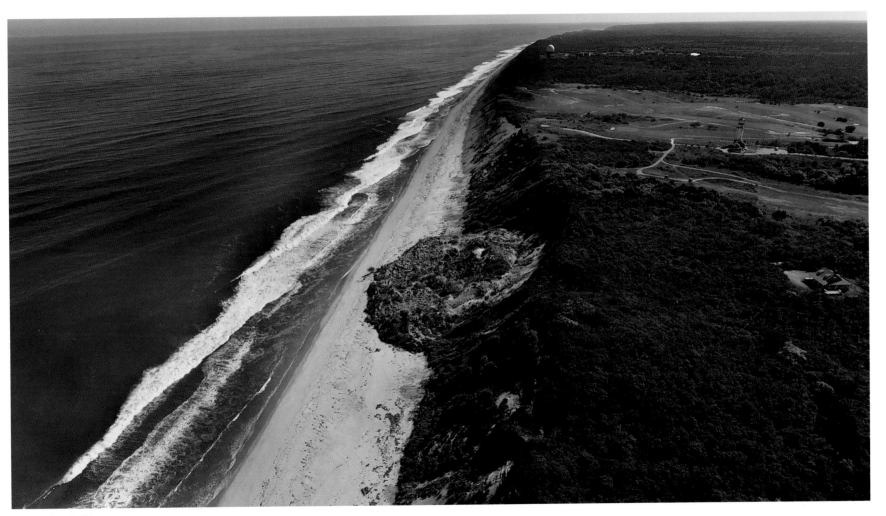

Highland Light bluff, Truro

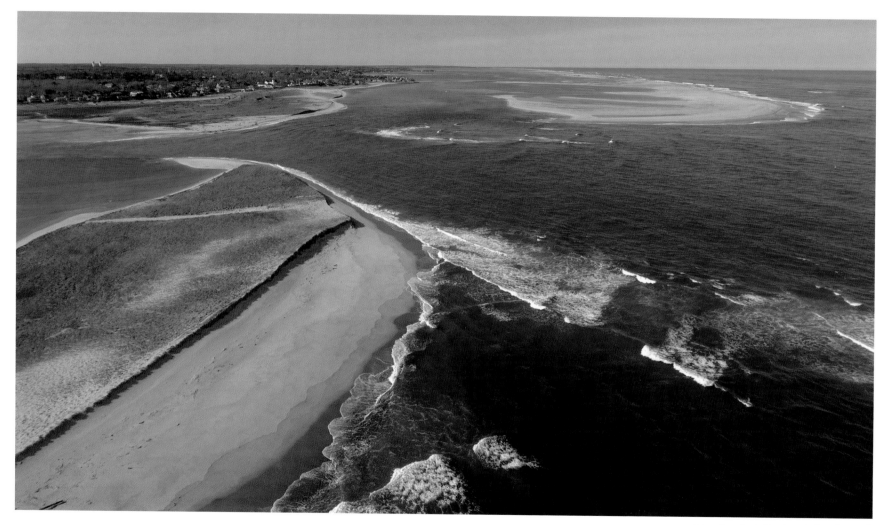

New break at Chatham's South Beach

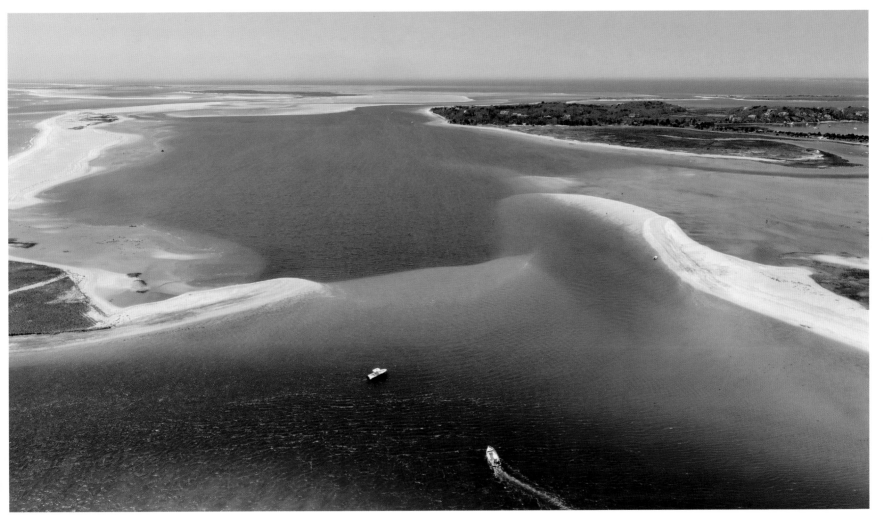

Reverse view of Chatham's new break

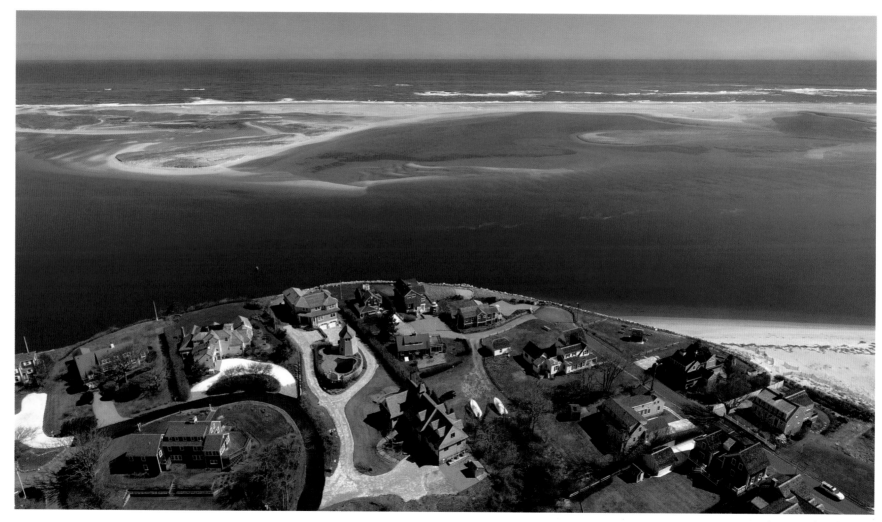

Shore Road at Chatham

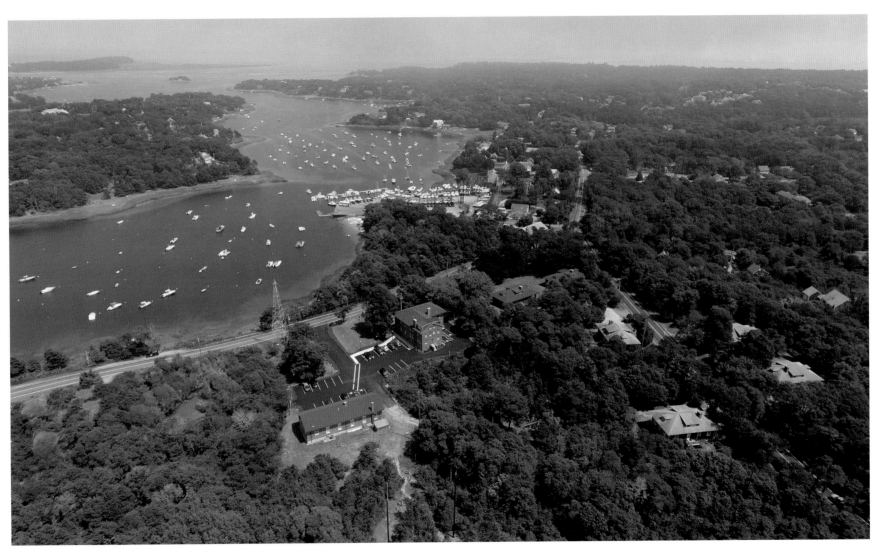

Chatham Marconi Maritime Center, Chatham

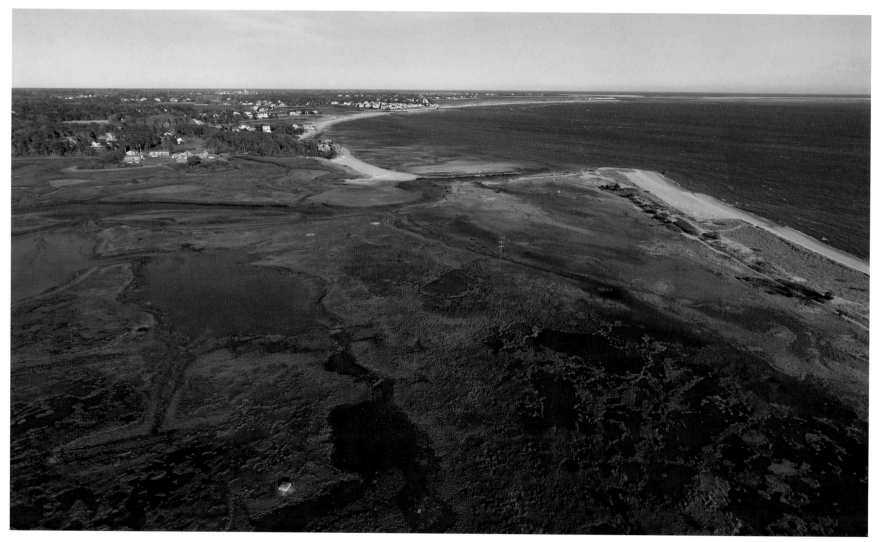

Forest Beach Marsh, Chatham

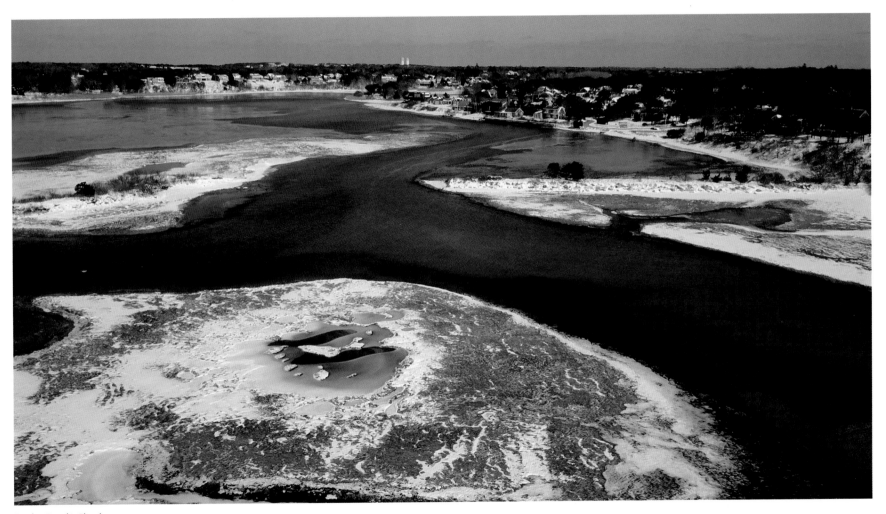

Bucks Creek, Chatham

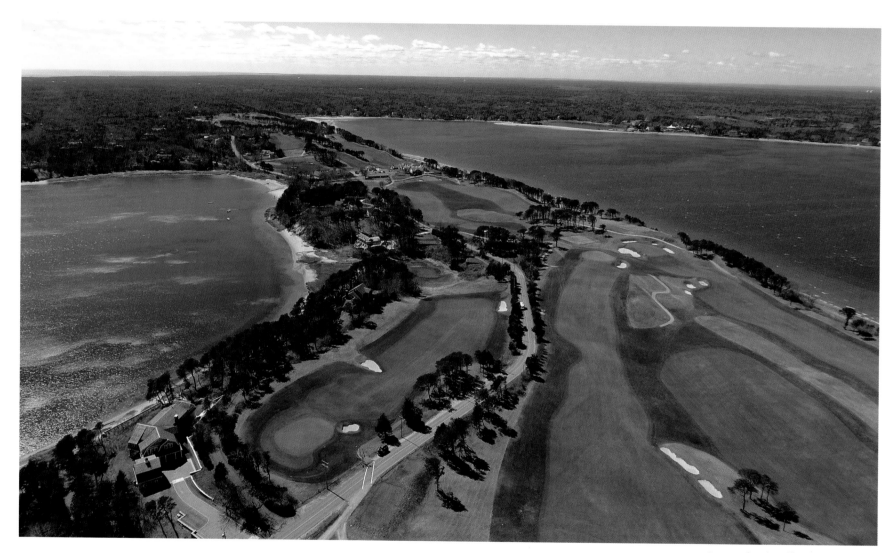

Eastward Ho! Golf Course, Chatham

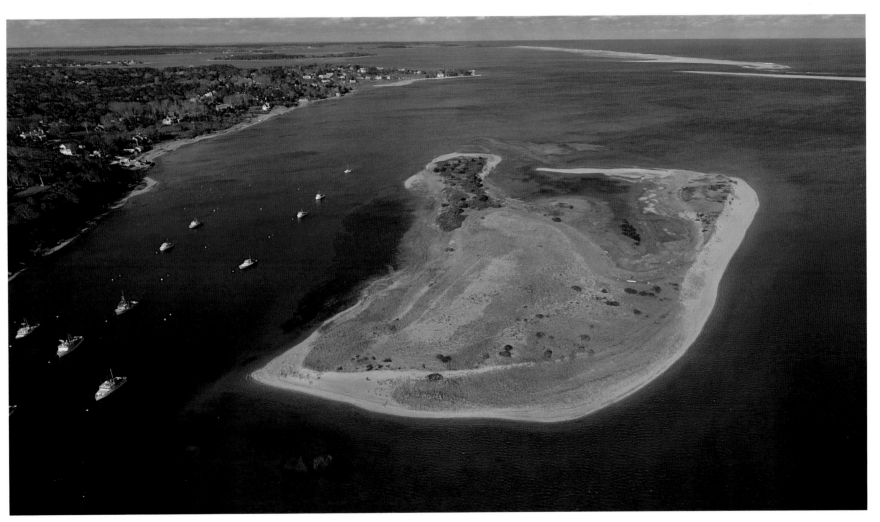

Tern Island, Chatham

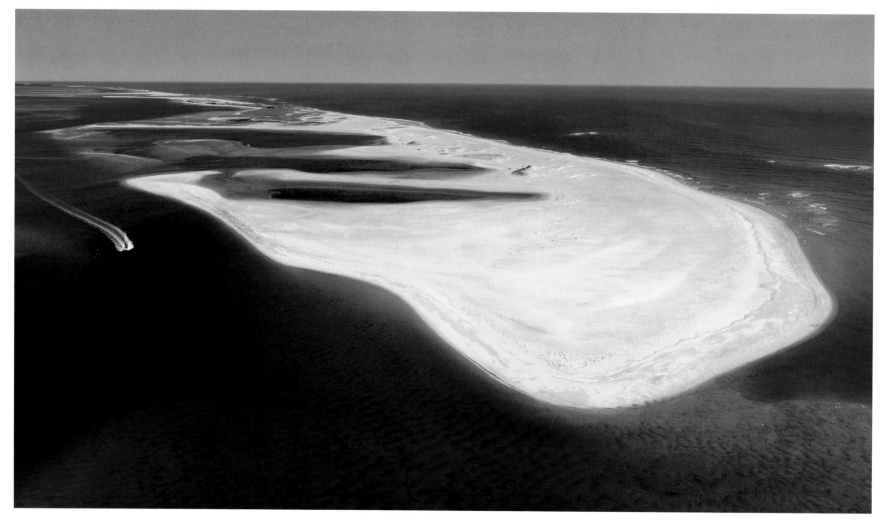

North Beach Island, Chatham

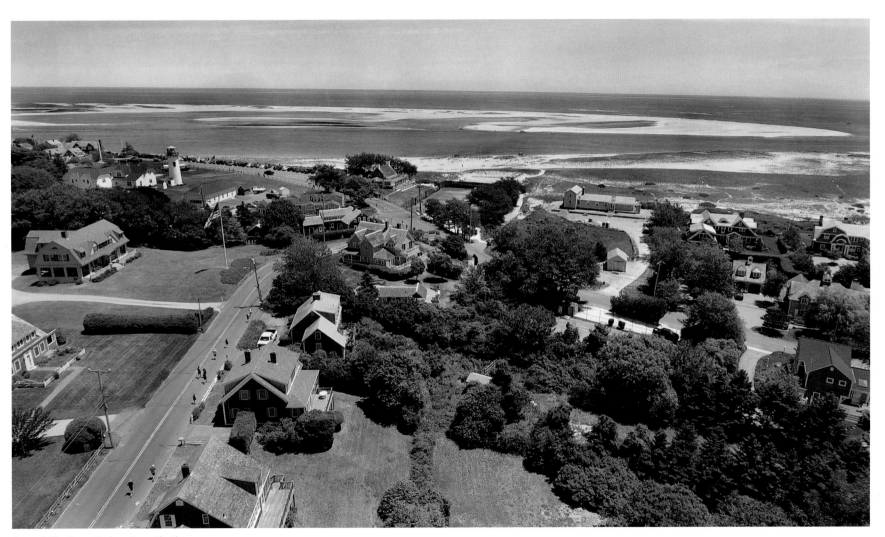

Annual Chatham Harbor Run, Chatham

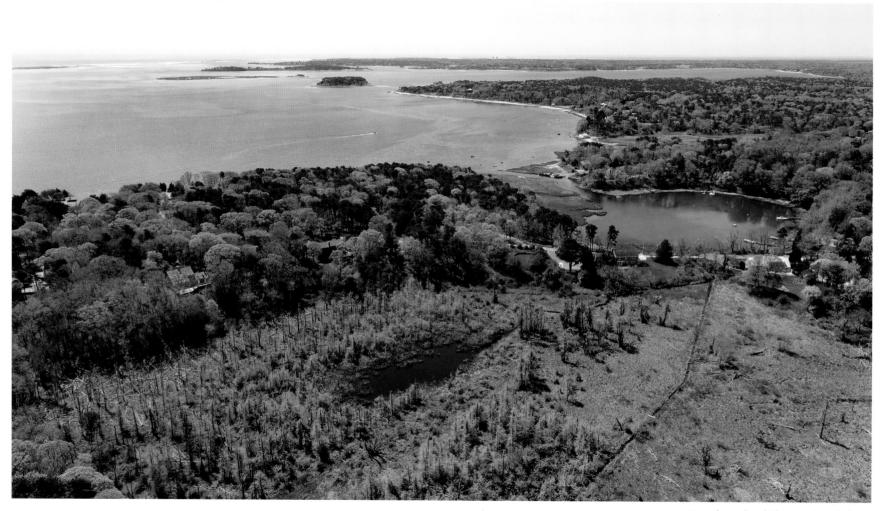

Vernal pond and Pleasant Bay, Orleans

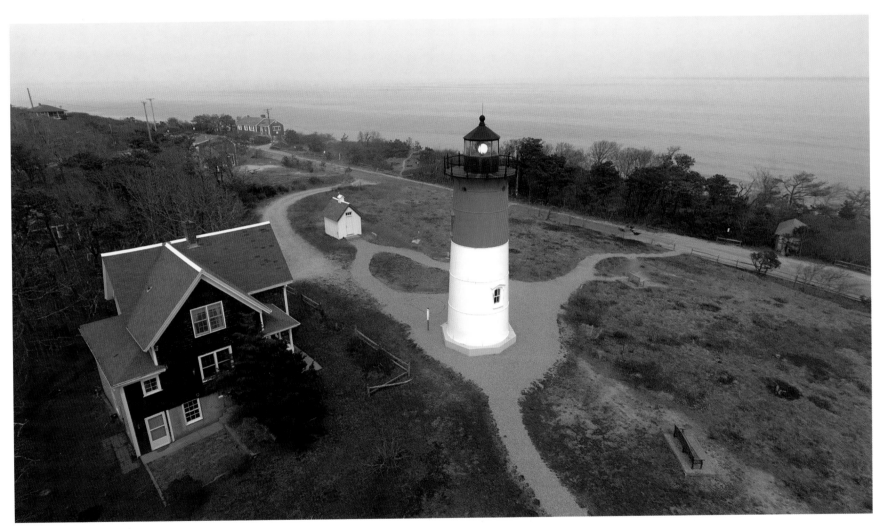

Nauset Lighthouse, Eastham

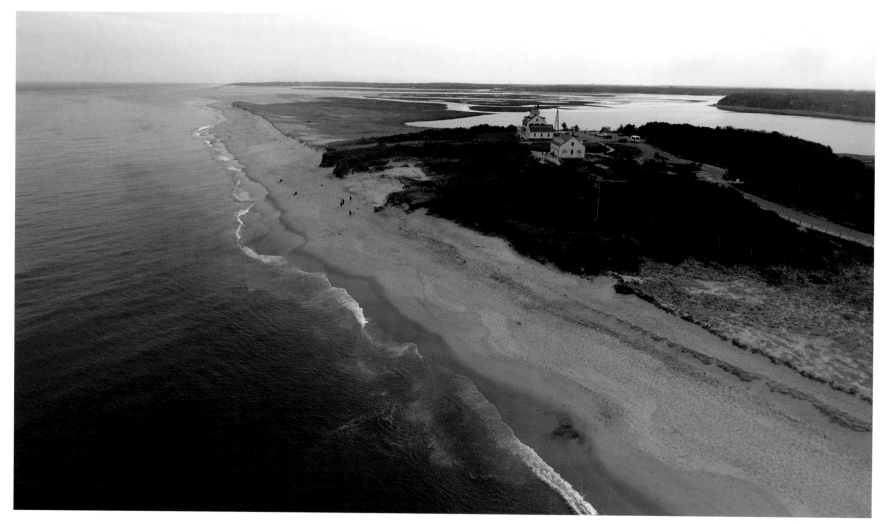

Coast Guard Beach, Eastham

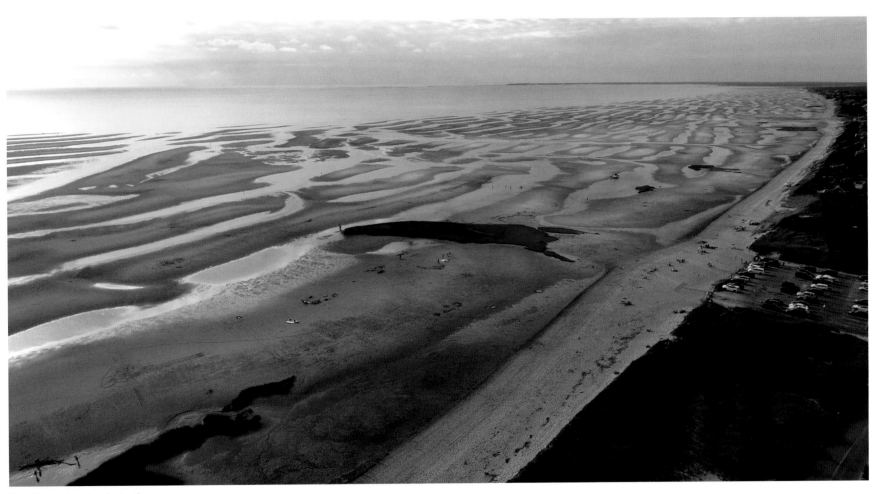

First Encounter Beach, Eastham

Edward Gorey House, Yarmouth

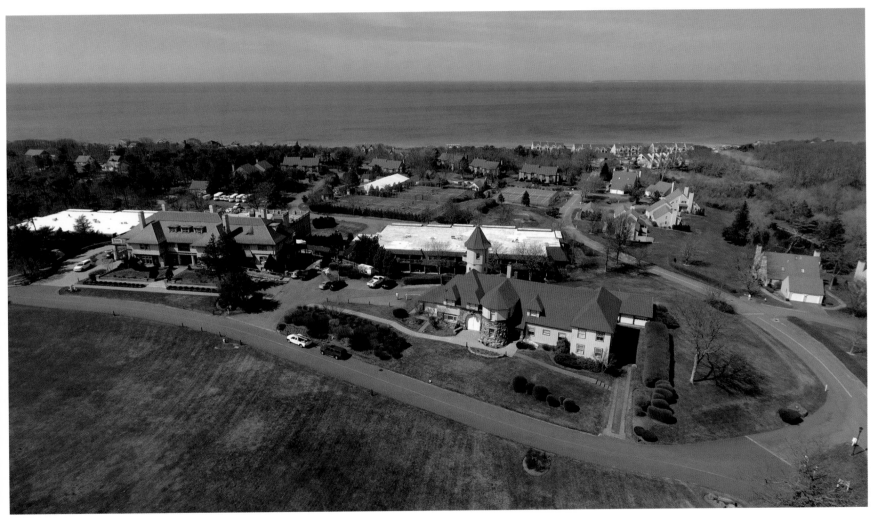

Ocean Edge Resort, Brewster

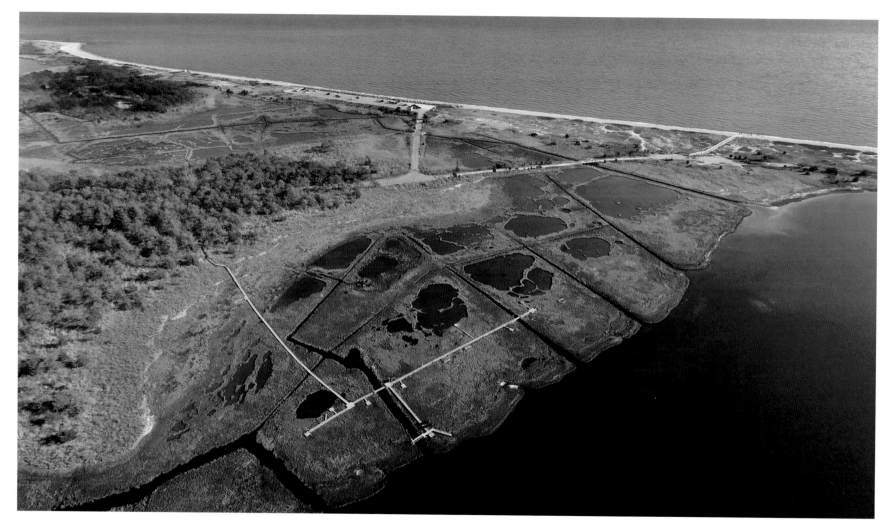

South Cape Beach, Mashpee

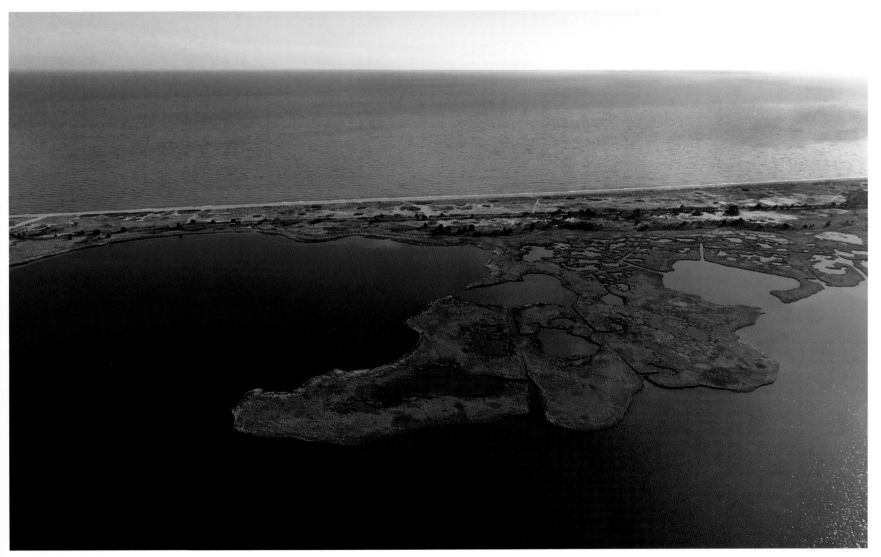

Dead Neck, Mashpee

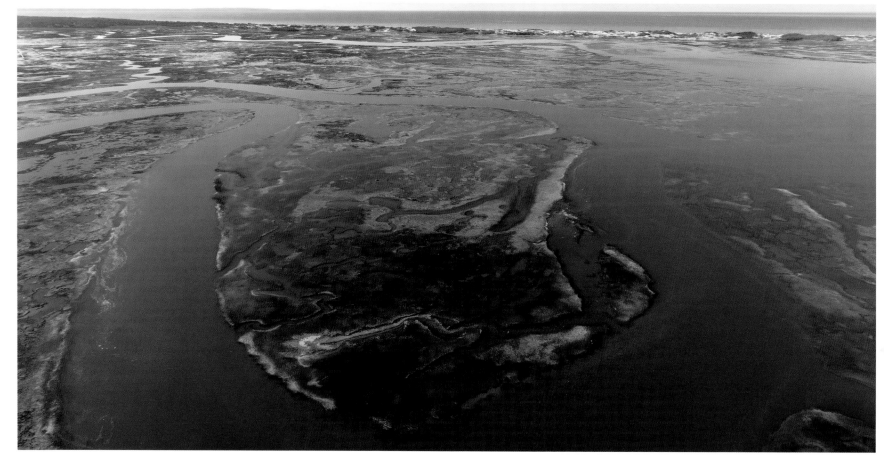

Great Marsh, Barnstable

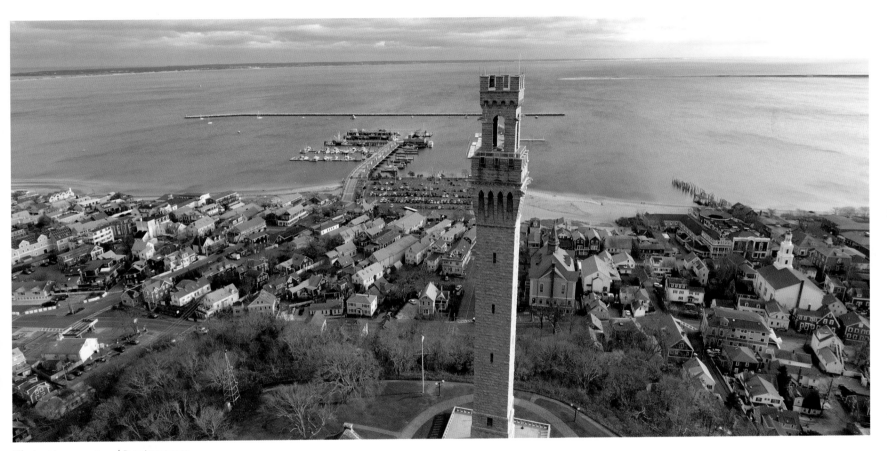

Pilgrim Monument and Provincetown

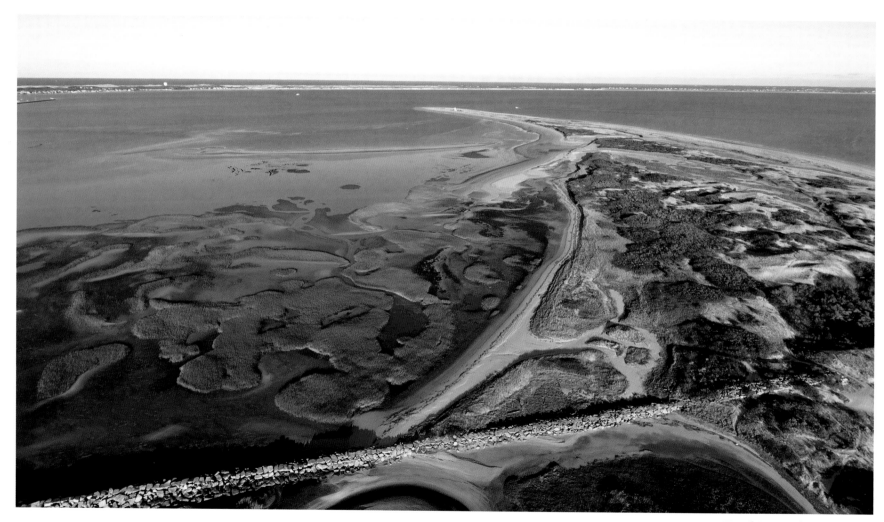

Tip of Cape Cod, Provincetown

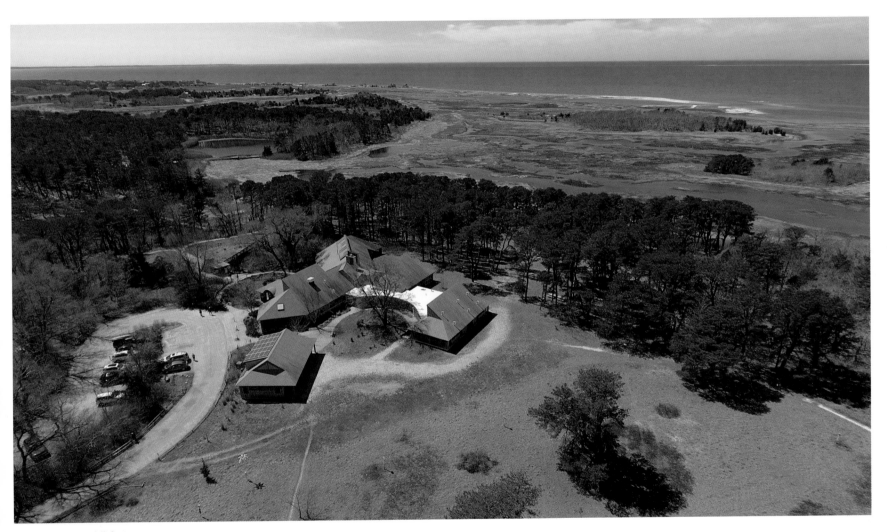

Wellfleet Bay Wildlife Sanctuary

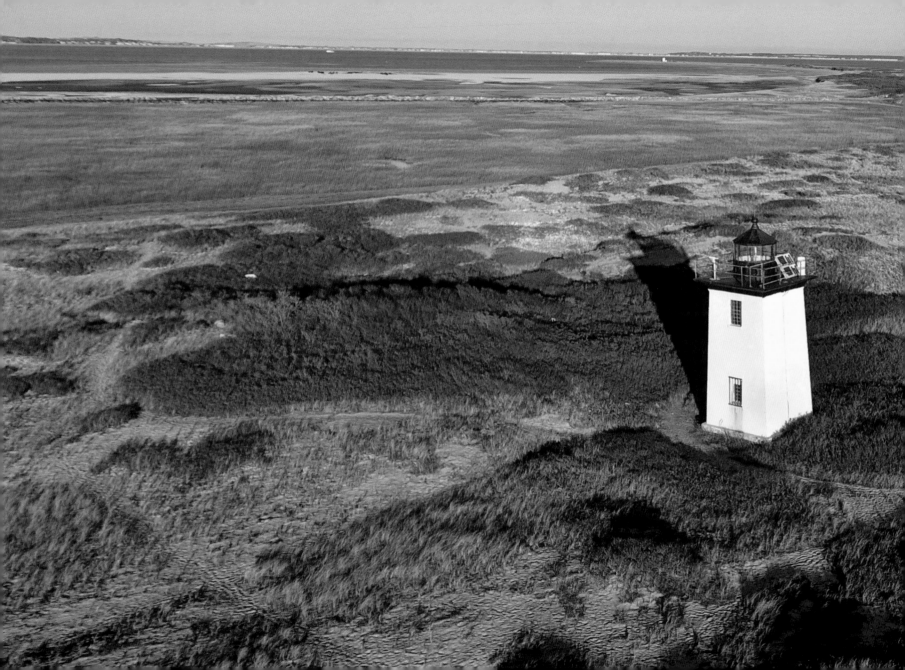

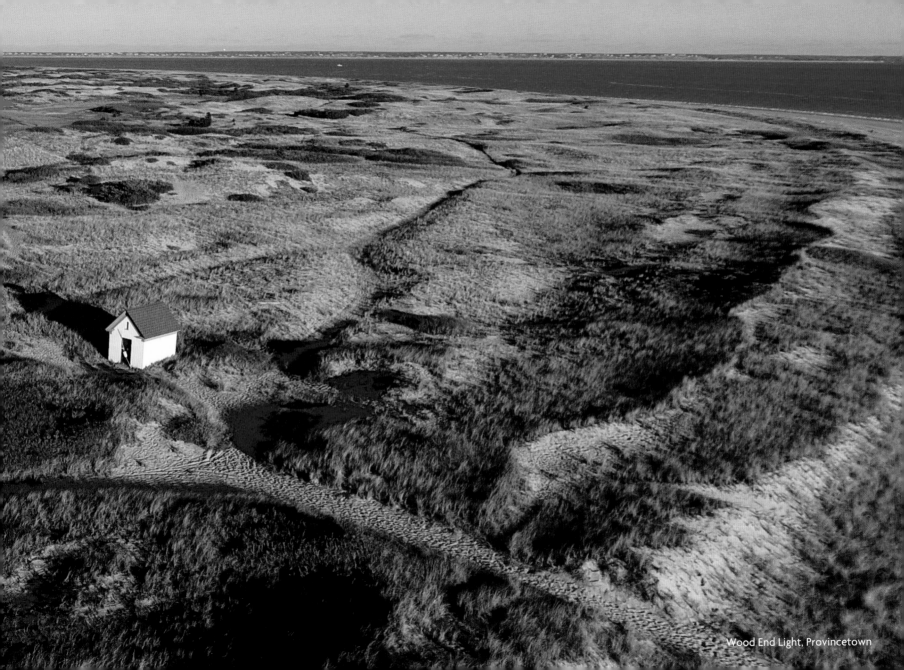

Wood End Light, Provincetown

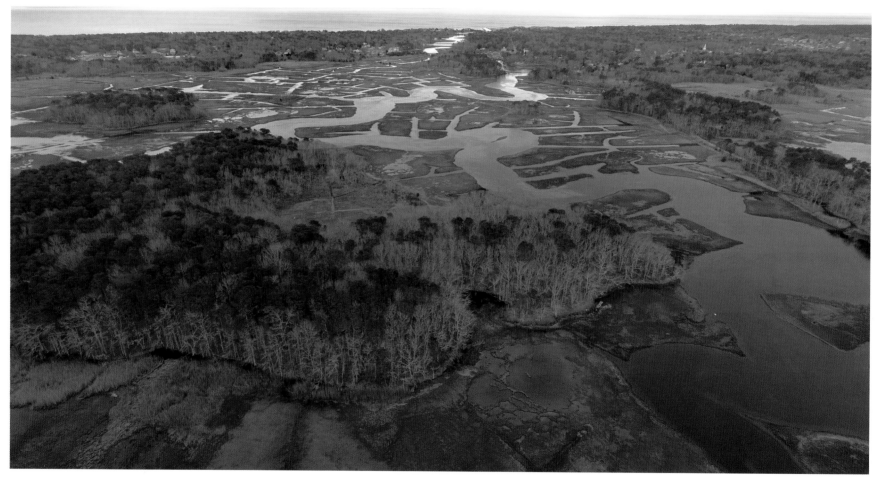

Bell's Neck Conservation Area, Harwich

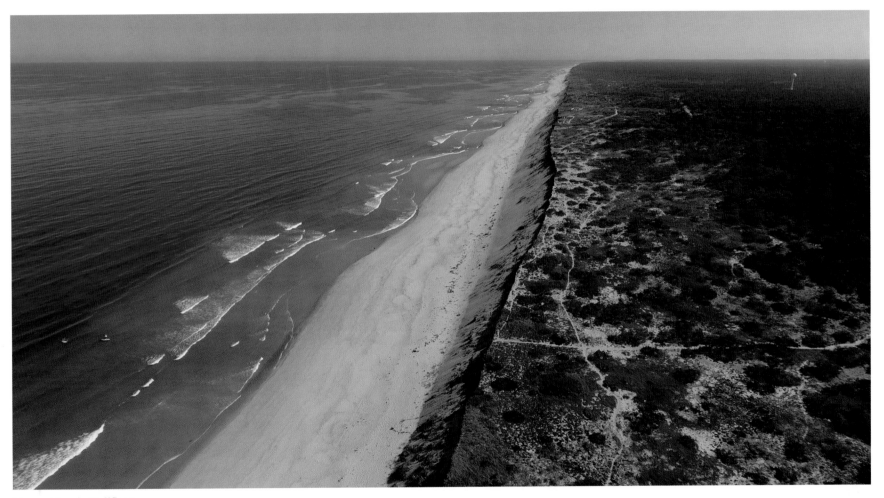

Marconi Beach, Wellfleet

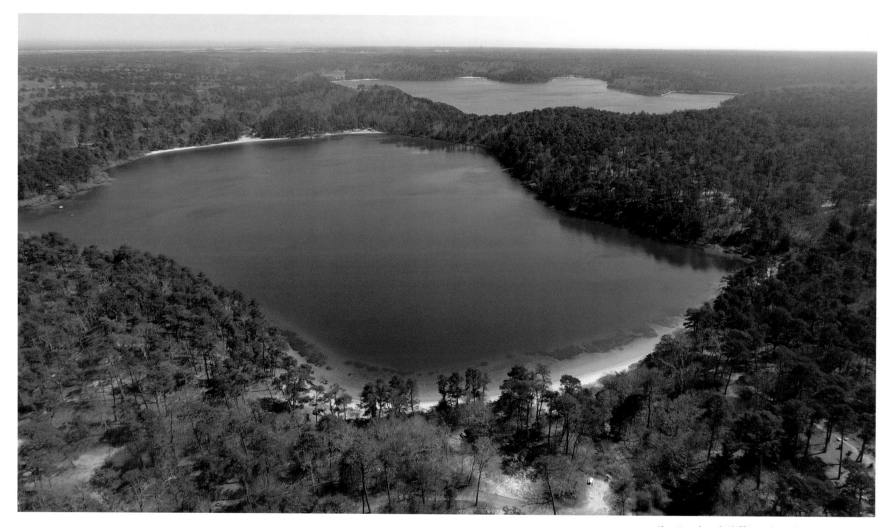

Flax Pond and Cliff Pond, Nickerson State Park

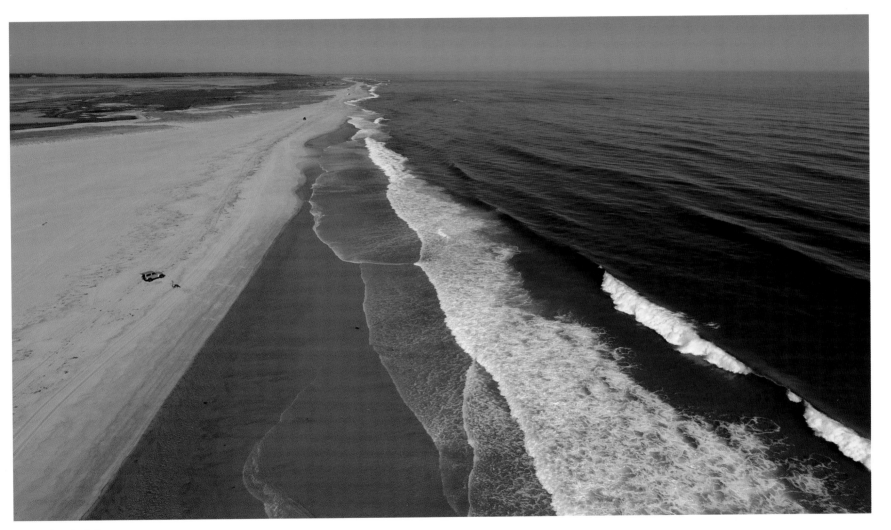

Nauset Beach, Orleans

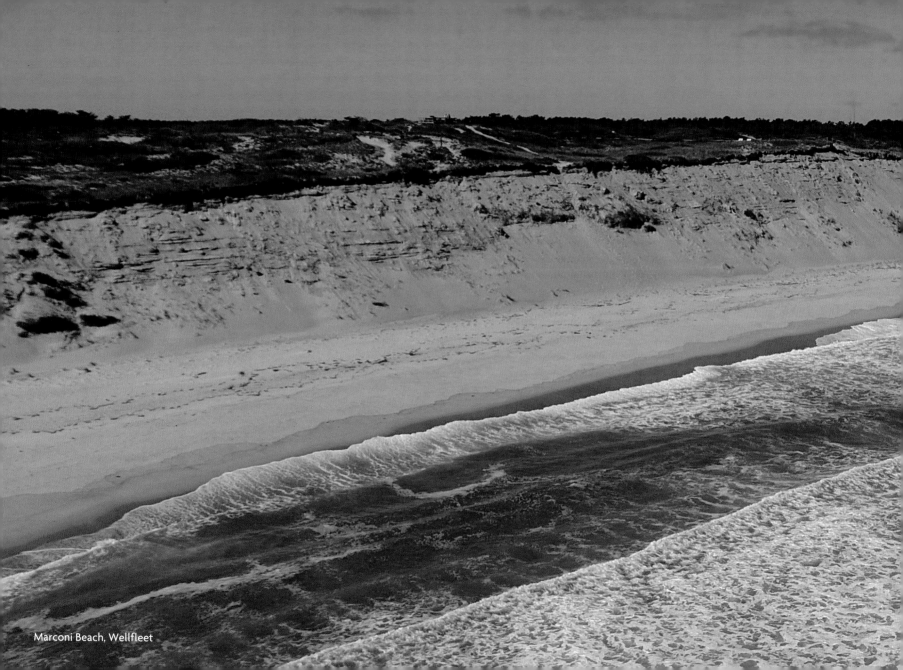
Marconi Beach, Wellfleet

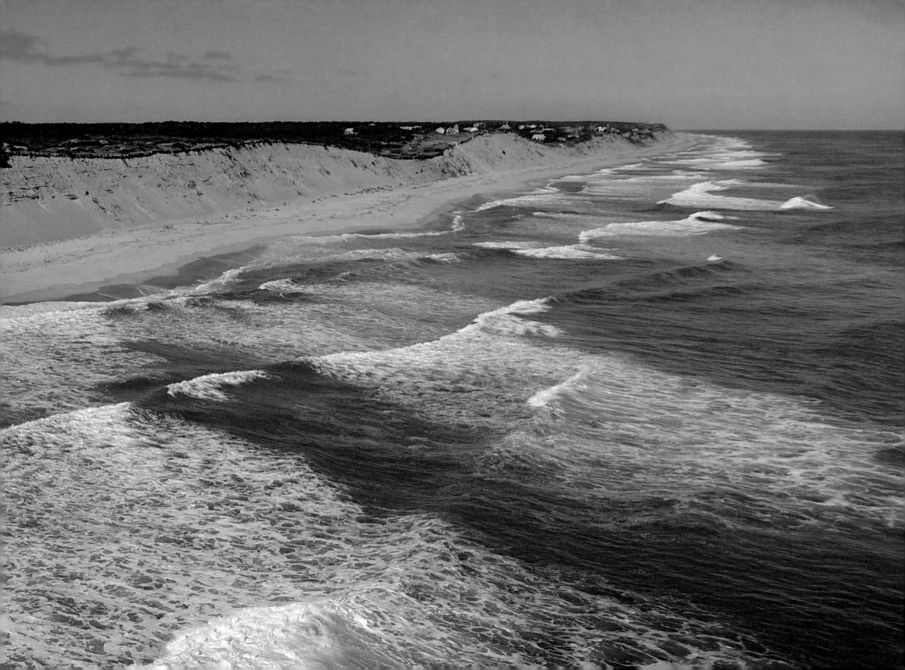

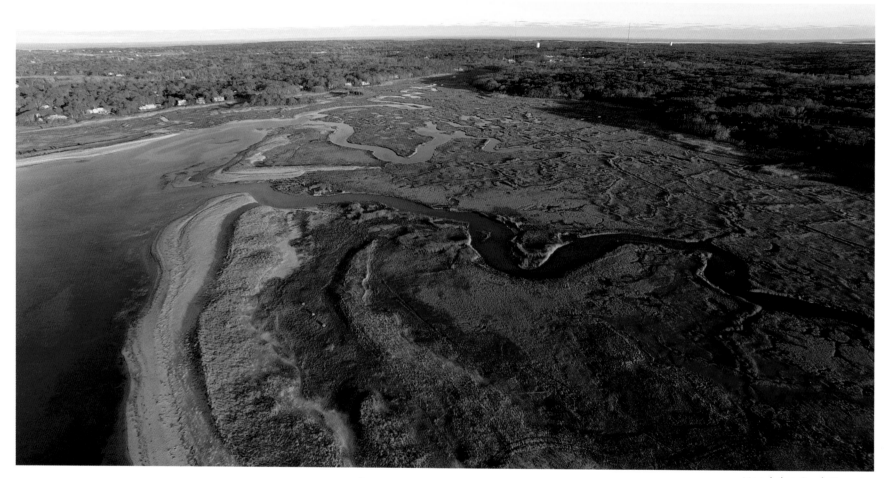

Namskaket Creek, Brewster

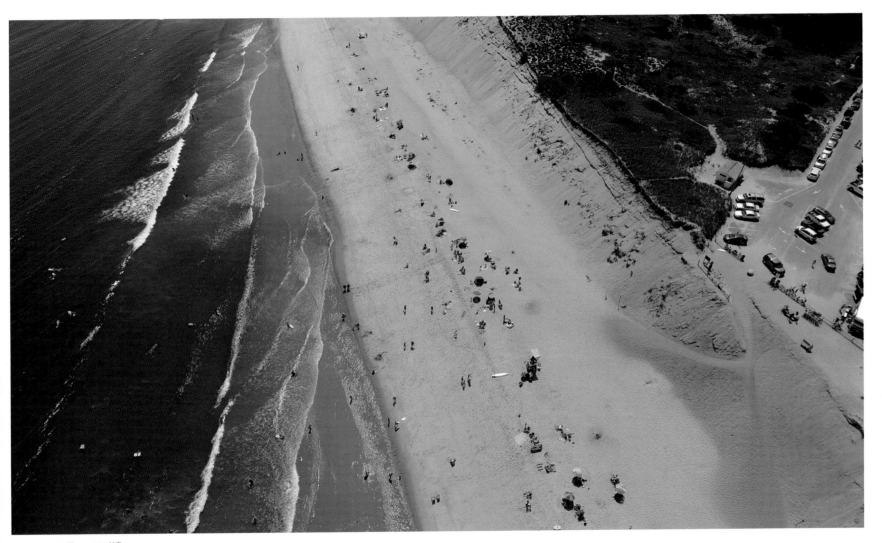

LeCount Hollow, Wellfleet

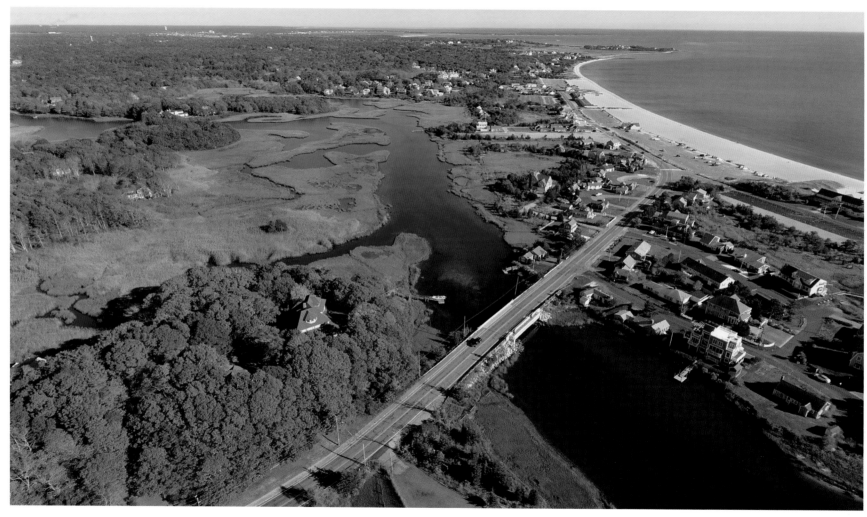

Craigville

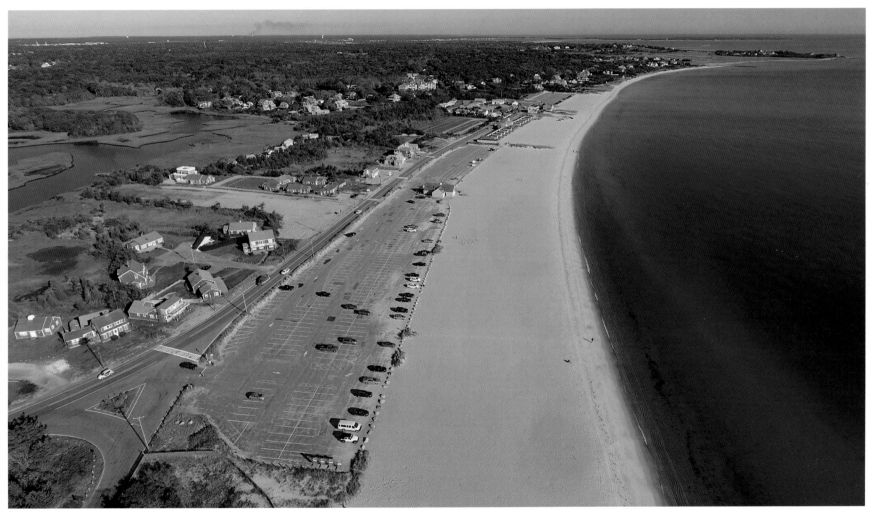

Craigville Beach

Christopher Seufert is a photographer based in Chatham, Cape Cod. He has been an aerial photographer since 1992, and received a commercial UAV license with the FAA in 2016. He is the author of six Cape Cod photography books, including *The Cape Cod National Seashore: A Photographic Adventure & Guide* (Schiffer 2012) and *Cape Cod & the Islands: Reflections* (Schiffer 2010). He leads custom photographic tours throughout Chatham, Cape Cod, and the national seashore. Seufert lives with his two children, Ethan and Stella, on the beach and runs Chatham Drone Solutions, www.CapeCodPhoto.net.